IMAGES
of America

MADERA

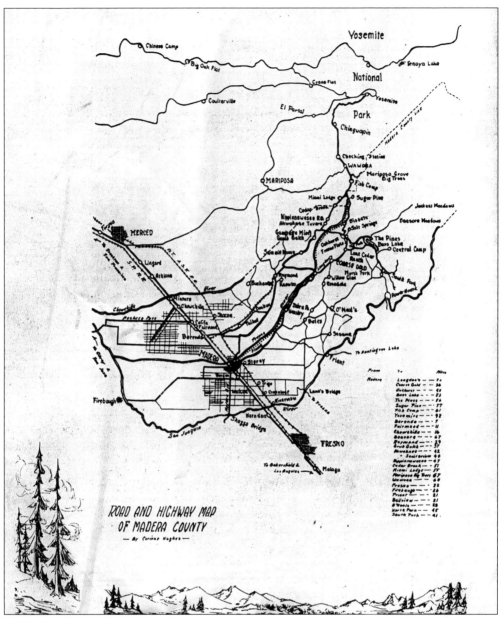

ROAD AND HIGHWAY MAP
OF MADERA COUNTY
— By Corinne Hughes —

This 1914 map of Madera County shows the town and its environs.

IMAGES
of America

MADERA

William Coate

ARCADIA

Published by Arcadia Publishing
Charleston SC, Chicago IL, Portsmouth NH, San Francisco CA

Printed in Great Britain

Library of Congress Catalog Card Number: 2005929127

For all general information contact Arcadia Publishing at:
Telephone 843-853-2070
Fax 843-853-0044
E-mail sales@arcadiapublishing.com
For customer service and orders:
Toll-Free 1-888-313-2665

Visit us on the Internet at www.arcadiapublishing.com

For Mary;
she cares.

CONTENTS

Acknowledgments 6

Introduction 7

1. Madera the Village: 1876–1900 11

2. Madera the Town: 1901–1920 63

3. Madera the City: 1921 to the Present 93

ACKNOWLEDGMENTS

As a relative newcomer to Madera County (1972), I am indebted to a host of friends who opened up the history of Madera to me. I will always be grateful to the late Richard Ryan of O'Neals for the many hours we spent touring the foothills of Madera County, meeting people and collecting history. Likewise, the late Floyd Park taught me much about the Chowchilla area of our county.

As far as Madera itself is concerned, it was my privilege to come on the scene just as an older generation was passing. I was able to meet and talk with many of them. The late Lena Adams and Carolyn Pitman provided me with many tools with which to explore Madera history. The Preciado, Mordecai, and Daulton descendants opened up their family archives and allowed some of Madera's most influential founders to speak to me from across the ages.

Two individuals who are still with us must be recognized. Genealogist Audrey Pool has, for 20 years, guided my research into the lives of Madera's pioneers, and my many lengthy conversations with Mr. John Sordi, Madera's pioneer banker and grape farmer, have erased many areas of ignorance from my mind. Any that remain are certainly not his fault.

Of course, a book such as this is not possible without the support of an archival institution; in Madera, this is the Madera County Historical Society. The society took over the old granite courthouse after it had been condemned and transformed it into one of the finest museums in the country (it has been placed on the National Register of Historic Places). The organization operates as a totally volunteer entity of mostly retired members dedicated to giving the necessary care to preserve thousands of exhibits and photographs.

Finally, following the pattern of literary acknowledgment, it behooves me to remark that any weaknesses to be found in this book are my responsibility; any virtues belong to my indefatigable editor, John Poultney. He and his colleagues at Arcadia Publishing have performed the herculean task of righting this manuscript while absorbing the tactical delays of a difficult author.

William S. Coate
Madera, California

INTRODUCTION

Madera started as a lumber mill town and owes its name and early economy to the boards it produced. In 1876, the first lots went on the auction block and the proposed village had its beginning, and in October 2005 Madera celebrated its 129th anniversary.

Actually, Madera was a Johnny-come-lately as far as towns go. When the Southern Pacific Railroad laid its tracks south through the San Joaquin Valley in 1872, it brought into existence the towns of Modesto, Merced, Minturn, Borden, and Berenda—but not Madera. Likewise, before Madera was even conceived, in the foothills the older mining communities of Buchanan and Grub Gulch flourished, as did the towns of Coarsegold, Finegold, and Fresno Flats (now Oakhurst) higher up in the mountains.

Finally, however, Madera came on the scene, and the announcement of its founding was greeted with something less than excitement, given the fact that it had no connection with mining and was not part of the Southern Pacific's plan for the San Joaquin Valley.

Madera's birth certificate was issued in a story in the October 11, 1876, issue of the *Fresno Expositor*. It read, in part, "The new town laid out by the California Lumber Company at the point where the company's flume intersects the railroad has been graced with the name of Madera—the Spanish word for lumber. It promises to be quite a flourishing town, and the demand for lots is great." The *Expositor* went on to report that a public sale of lots was scheduled to take place on Tuesday, October 24, at the town site. The lumber company was ready to bring its raw product down the recently completed flume, where it would be finished at the new planing mill. Everything was set; Madera was ready to roll.

One month later, county supervisor Hensley informed the *Expositor* that "building is going on at a lively rate at the new town of Madera. More than a dozen buildings are in the course of construction, and others will be built as soon as workmen can be obtained. The continuous sound of saw and hammer and the busy activity of the workmen impart a prosperous, business-like appearance to the town."

On January 10, 1877, the *Expositor* sent a reporter to Madera to determine precisely for himself the current status of the valley's newest burg. What he found was astounding. From the sands of the Fresno Plains, in a matter of weeks, a town had arisen where formerly only jackrabbits and antelope played. "But a few weeks ago there was not a dwelling within a mile of here," noted the reporter. "Today there are probably 25, some of which are better by far than the casual observer would at the first glance believe could be built and fitted up in such a short time."

The most "pretentious," according to the reporter, was a house erected by a Mr. Jason that was used as a hotel. Jason was apparently in the process of expanding his building in order to make it a true hotel, both in name and substance. The next building in size was Captain Mace's saloon. It was a rectangular structure, 24 feet by 56 feet, with the long side facing the mill reservation, which became Yosemite Avenue. Apparently Mace was also busy transforming his building into a first-rate hotel, for the reporter asserted that "the Captain intends making certain additions in the

spring." Evidently he was successful, for it was the jocular Mace who is credited by all responsible historical authorities with owning the first real hotel in Madera.

Next to Mace's saloon, in these early months of Madera's existence, was a saloon built by C. E. Strivens. It was reported to be a comfortable, neatly fitted-up saloon, and its owner was said to be making himself generally agreeable to all comers. Just beyond Striven's place stood a small building owned by a Mr. Sanford.

Across the Southern Pacific Railroad tracks to the west was the public house of Mark Anderson, which was adorned with a "bold and artistically formed sign which bore his name and indicated that he was there to do business in his old friendly way, so familiar to the good people of the whole country round about." At this time, there were no merchandise stores in Madera, although there were about 20 private residences.

As promising as the up-and-coming town of Madera appeared, not everyone welcomed this upstart newcomer. The *Expositor* reported, "Just a slight tinge of jealousy is now and again manifested between Borden and Madera." This apprehension on the part of the citizens in the town just four miles south of Madera was well justified. In a few short years, it would be totally eclipsed by its lumber town neighbor.

Within a few months, the residents of Madera were thinking about the education of their youth. On March 21, 1877, a public meeting was held to discuss the erection of a school building. Those early Maderans decided that evening to begin work at once. The building was 50 feet by 30 feet, had a 16-foot ceiling, and embraced all of the "modern improvements." The school was built on two acres of land and was fenced and planted with numerous shade trees.

By April 1877, Madera, having no newspaper of its own, was receiving regular press coverage in the *Fresno Expositor*. Under the heading of "Madera Items," it was reported that a drove of antelope had crossed the railroad tracks at Madera on April 4. Additionally, C. H. Evans had built a handsome veranda in front of his saloon and planned to cover it with an awning like the one above the entrance to the El Capitan Hotel in Merced. Further, Dr. Brown had purchased Sanford's saloon, poured the whiskey out into the dirt street, and fitted up the building as a drugstore. So, within half a year of its founding, the town of Madera began building its destiny, but not without some growing pains.

Although the lumber industry gave birth to the town of Madera, for a while that enterprise was just barely alive. Twice its heartbeat almost ceased, and it was only through the courage of a handful of citizens that it was resuscitated.

Within a year after the founding of Madera by the California Lumber Company, the business and town found themselves in deep trouble. The devastating drought of 1877 created a panic throughout the entire San Joaquin Valley as lumber piled up in the new Madera yards awaiting customers who never came. On February 20, the short-lived operation was declared bankrupt, and its properties passed to a San Jose bank.

On May 21, 1878, the officers of the bank, led by a man with the unusual name of Return Roberts, incorporated another lumber company called the Madera Flume and Trading Company. This successor to the California Lumber Company continued the Madera logging operation and helped save the town from an early death. Two sawmills were constructed in the mountains, and soon lumber was once more making its way down the flume to the new little village of Madera. Adversity, however, remained poised and always threatened.

In 1881, a disastrous fire completely destroyed the lumberyards in Madera, and in the 1890s a nationwide depression put the Madera Flume and Trading Company on the verge of extinction. Along came Elmer H. Cox, who with Return Roberts and Michigan lumber magnate Arthur Hill, formed the third major lumber company in Madera. Under Cox's astute direction, the Madera Sugar Pine Lumber Company was incorporated, and on May 8, 1899, it took over the assets of the Madera Flume and Trading Company.

The old lumber flume was rebuilt and extended. Logging techniques became more sophisticated as a narrow-gauge railroad was brought into the woods to enable loggers to cut timber at greater

distances from the millpond. By the 1920s, seven locomotives were needed to bring timber to the mill.

The Madera Sugar Pine Lumber Company existed for more than three decades and made money nearly every season. It harvested more than 50 million board feet of timber annually and continued to pump life into Madera. Then in 1931, economic depression again raised its ugly head. Once more a nationwide depression destroyed the market for lumber, and the last log was finally cut.

Although the Madera yards continued to function for two more seasons, the mountain camp was closed for good. In due time, the locomotives, mill equipment, and other properties were sold, and the corporation known as the Madera Sugar Pine Lumber Company quietly disappeared. Today little remains of what was once the single most important economic force in Madera.

For more than 50 years, the fortunes of Madera were inextricably bound to lumber; from 1876 to 1933, the town was nourished by timber. To a large degree, it was the resiliency of the industry that kept the town alive. By the time the death knell sounded for lumbermen, the farmers, who already had been contributing to the economy for many years, stood ready to fill the gap. Diversified agriculture took up where lumber left off, and today Madera and Madera County harbor a rich farming economy.

Its eventual demise notwithstanding, the Madera Sugar Pine Lumber Company continues to be remembered. Its role in Madera's history is too important to be forgotten. The legacy of its lumberjacks and the men who worked the mills in Madera will always enrich her story.

Today Madera is a city of more than 45,000 residents. Over 17,000 students are educated in its school system, and at its outskirts is a junior college. It has become the hub of the county as its seat of government. On the rim of the city are modern shopping complexes where cotton and grapes once grew and cattle grazed.

Meanwhile, as the centrifugal economic forces continue to spin outward from Yosemite Avenue, which was once the heart of Madera, the downtown area has changed. With the exception of two or three landmarks, today there are few reminders on Madera's main street of the days gone by. This is why this author and his publisher have undertaken this project—to assist us in remembering the way we were.

As one contemplates Madera through the pages of this book, a clear view of the town's future will elude us, but its past is secure. For that reason, reflections on our yesteryears will always pay dividends.

One

MADERA THE VILLAGE
1876–1900

In 1876, George Armstrong Custer was killed, Rutherford B. Hayes won the U.S. presidency, and the town of Madera was born. Rocked in the cradle of a wooden flume that carried lumber from the mountains 60 miles away, Madera grew very quickly, and its economic base broadened. Visitors began to converge on the town by the hundreds, choosing its route to Yosemite Park. Shortly thereafter, irrigation gave an impetus to agriculture, and by the time it was 15 years old, Madera was a thriving little village of 1,500 residents. With lumber, tourism, and agriculture pumping its economy, Madera was now ready to fulfill its destiny.

That destiny, however, did not lie in economics alone. Madera had a political destiny as well. By 1890, the rumblings of discontent could be heard in Fresno County's First Supervisorial district, of which Madera was a part. Most of that dissatisfaction centered in and around the new lumber town and a cast of characters that would play their roles in turning the village into a town by creating Madera County and making Madera its county seat.

On March 10, 1890, the *Madera Mercury* reported, "In the near future a new county will be formed, and . . . it stands to reason that it (Madera) will be the county seat." It was another two years before the Fresno papers acknowledged the fact that Madera residents were laying plans for carving off a piece of Fresno County.

The Rubicon was crossed by those in favor of the creation of Madera County on January 28, 1893. A meeting had been called in Fresno's Kutner Hall to determine the sentiments of Fresno County voters, and at approximately 6:00 p.m. a special train pulled into Fresno from the north. It was filled with Maderans who were intent upon making their will known.

The *Fresno Expositor* described the meeting and its participants as "the wildest, the most tumultuous body of men ever assembled in this city." It was reported that the Maderans had been instructed to yell like devils, which instruction they apparently followed to the letter.

E. H. Cox, Return Roberts, H. C. Daulton, John Griffin, Sen. George Goucher, and Assemblyman George Washington Mordecai led the fight for division. Daulton, who had served several terms as chairman of the Fresno County Board of Supervisors, rose and made a case for division.

"This county (Fresno) is too big . . . large enough almost to make two states. We now have two daily papers in Madera, and we simply ask you to let us go in peace. We want a divorce from you, and we don't want you to pay any alimony."

"If my wife were to tell me that two-thirds of her wanted to go away from me, and she didn't want any alimony, it would be a very cruel thing if I didn't let her go, although my wife is very dear to me, and she has given birth to every child I have."

As a result of such vigorous participation of the Madera residents, the meeting at Kutner Hall ended with the adoption of a resolution in favor of the division of Fresno County, which was forwarded to the California State Legislature. The Bill to Create Madera County was introduced by Assemblyman Mordecai and passed on February 25, 1893. A commission was appointed by Governor Markham to oversee the organization of the new county, provided the voters of the area approved.

An election was set for May 16, 1893. On the ballot were two pivotal issues. First, should Madera County be created from Fresno County, and if so, where should the county seat be located?

Not everyone in the area wanted Madera to be the seat of government of the new county. Some of the hill folks made a move to place the county seat in the high country. Near the present-day junction of Roads 400 and 406, a piece of land was selected, and the town of Minarets was laid out on paper. It was to be a "pretentious community" with 80-foot-wide streets and a central square for a courthouse.

The vote on the creation of Madera County was overwhelming: 1,179 in the affirmative and 368 in the negative. In the matter of selecting the county seat, Madera reached its 19th-century apex. By a vote of 1,065 to 567, it carried the day, and its path into the 20th century and beyond was clear.

Fortune had continued to smile on Madera. Its boosters had seized the moment and catapulted it into a position of inevitable leadership. An upstart and a latecomer, the place had risen from humble origins. Now, just as it was beginning to look like a village, it quickly became a town.

One can speculate on what would have happened if Minarets had been chosen. No doubt the town would have been built, and the center of political gravity would have been in the foothills of Madera County. Just as probable, Madera could have drifted off the map like Minturn, Berenda, Borden, and other Madera County ghost towns.

Therefore, as one considers Madera in its first 25 years, it must be remembered that, although its economic raison d'etre lay in its connection to lumber and agriculture, it was its position as county seat that insured its existence.

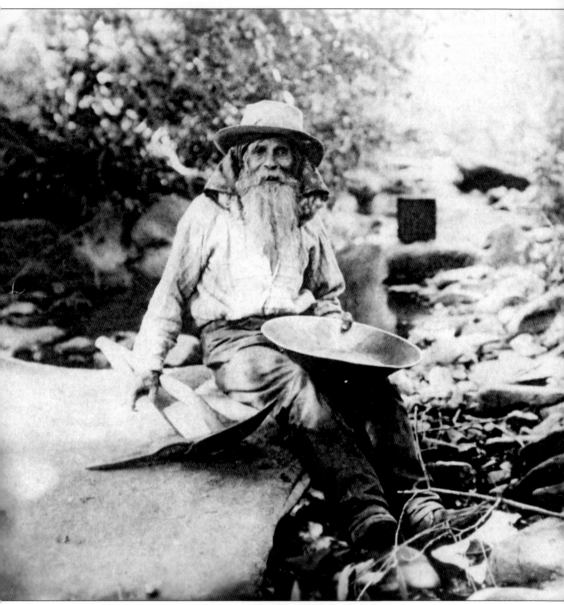

Alapoleno, also known as Santa Claus, poses in the 1880s. Seen here on Coarsegold Creek with the tools of his trade, a gold pan and pick and shovel, the one-time cook for Joaquin Murrieta spent a good portion of his adult life looking for gold in eastern Madera County. Ironically, William Henderson, the man who is credited with shooting Murrietta, also lived on Coarsegold Creek. It is not known whether the two men met each other or not.

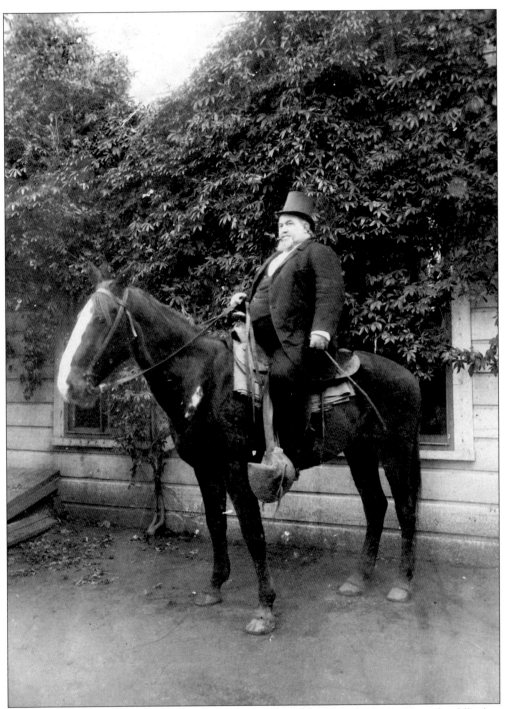

Pictured c. 1885, Capt. Russell Perry Mace, an avid horseman who rode with a special saddle that accommodated his 350-pound frame, purchased the first lot in Madera in October 1876 and built the town's first hotel on it a few months later. Often seen with a top hat and cigar, Mace served three terms in the California State Assembly. Upon his departure, the legislature presented him with a huge rocking chair, which is now on display in the Madera County Museum.

William H. Thurman, pictured here c. 1893, was one of the founders of the California Lumber Company, which gave birth to Madera. It was Thurman who gave the town its name (Madera is the Spanish word for lumber). Thurman also invented the flume clamp, which made it possible to bring lumber down the flume in bundles. When Madera County broke away from Fresno County in 1893, the voters chose Thurman to be their first sheriff. He died two years later.

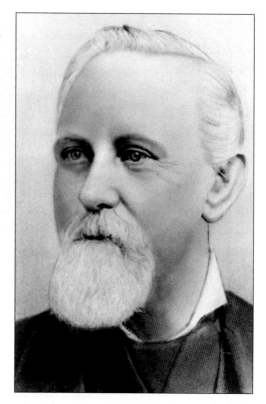

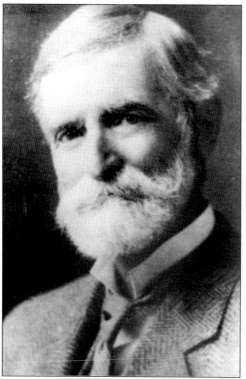

George Washington Mordecai was Madera County's first assemblyman. In February 1893, around the time of this photograph, he introduced the bill to create Madera County. A native of Virginia who fought in the Civil War, in 1868, he came to the San Joaquin Valley and began farming and raising sheep. Through sheer determination and an indefatigable spirit, he prospered, and at the time of his death he was one of Madera's most prominent citizens. His ranch, which he called "Refuge," has been preserved by his descendants and is a working ranch today. Mordecai is buried in the family plot on the property and the epitaph on his tombstone reads, "He served with Lee and Jackson and surrendered at Appomattox."

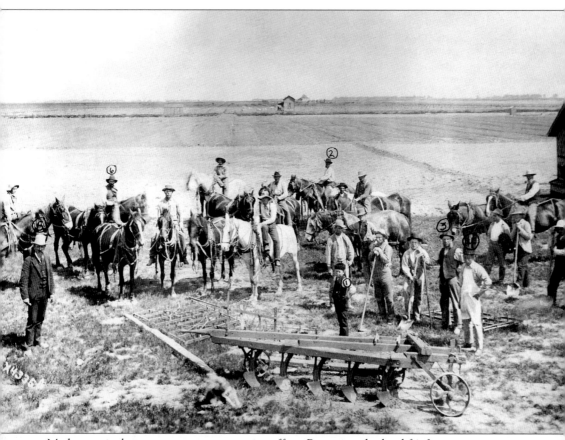

Madera agriculture was once a cooperative effort. Preparing the land for farm use was never an easy task, as this c. 1890 photograph shows. Here a crew in the Howard District prepares for a hard day's work. Several of the people in the photograph are identified by numbers in circles above their heads, including Will Houlding (1), Thomas Houlding (2), Robert Houlding (3), the Chinese cook (4), Mr. Worthington, the boss (5), and George Kopp (6).

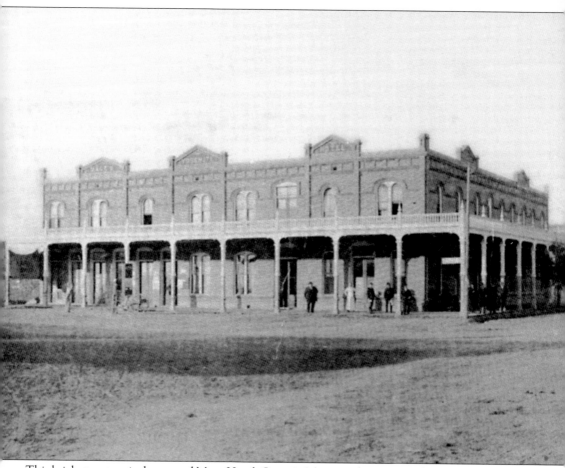

This brick structure is the second Mace Hotel. Captain Mace can be seen standing near the center of the photograph wearing his hat. The first building was a frame structure that burned in the disastrous fire of 1885. This corner lot upon where the hotel was located was the first property in Madera sold to a private citizen. It now is the home of a furniture store.

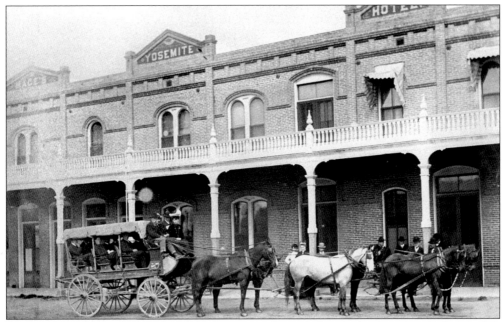

Madera was just a few years old when the Yosemite Stage and Turnpike Company built a road to the mountains and began to transport tourists from Madera to the Mariposa Grove of Big Trees, Wawona, and Yosemite Valley. Captain Mace's Yosemite Hotel, pictured *c.* 1885, was the western terminus of the route. In 1879, Pres. Ulysses S. Grant caught a stage just like the one shown here and journeyed eastward to see the wonders of Yosemite.

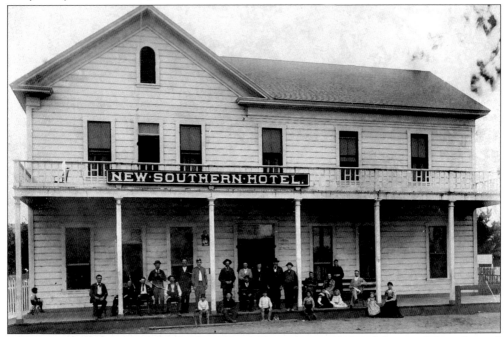

Near the turn of the century, the Southern Hotel (shown here *c.* 1890 and above right) was located on Madera's North B Street. With a plank sidewalk running in front, the frame structure sat east of Curtin's livery stable. Today World Savings Bank stands on the site.

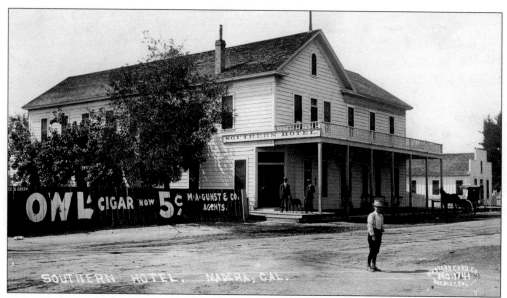

Most of the time, it was business as usual at the Southern Hotel, but one time the proprietor, J. M. Hambleton, became the unknowing participant in one of the wildest scams attempted in Madera. Jack Barnes, one of the hotel guests, took off in the night without paying his bill. A few days later, Hambleton received a letter purporting to be from one J. J. Leary, who owned a hotel in Reno, Nevada. Leary informed Hambleton that Barnes had committed suicide in his hotel. Unfortunately for Barnes, Hambleton recognized by the handwriting that the letter had been composed by the fugitive. He turned it over to the Madera sheriff, who then went after Barnes.

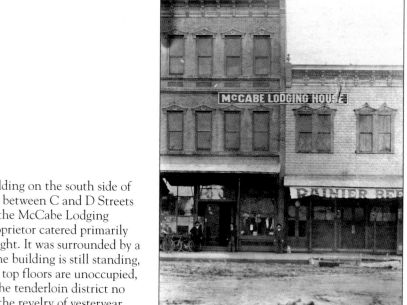

The Barcroft Building on the south side of Yosemite Avenue between C and D Streets was the home of the McCabe Lodging House, whose proprietor catered primarily to ladies of the night. It was surrounded by a dozen saloons. The building is still standing, although the two top floors are unoccupied, and residents of the tenderloin district no longer engage in the revelry of yesteryear.

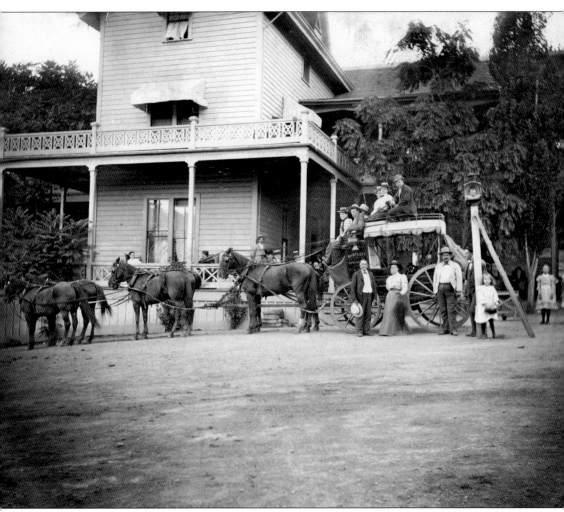

The Vignolo Hotel in Berenda, a few miles north of Madera, was a major stagecoach stop in the 19th century. On the day this photograph was taken, *c.* 1885, the tourists who were about to climb aboard the stage were surprised by a bloodcurdling scream of a mountain lion that had made its way down from the mountains. The animal was shot by Herman Crow, and the travelers resumed their journey without any coaxing from the driver.

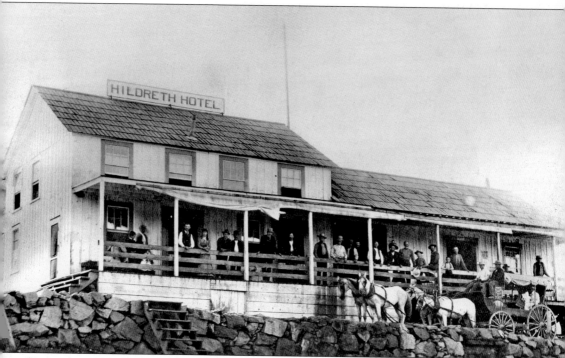

Pictured *c.* 1880, the Hildreth Hotel was a resting place for travelers and a watering hole for hard-rock miners who worked in the area. Hildreth was situated in the foothills to the southeast of Madera. It was a typical frontier hotel in a typical frontier community, with its fair share of fist-fights, brawls, and shoot outs. Today nothing remains of the hotel, which was located on the William Ryan Ranch.

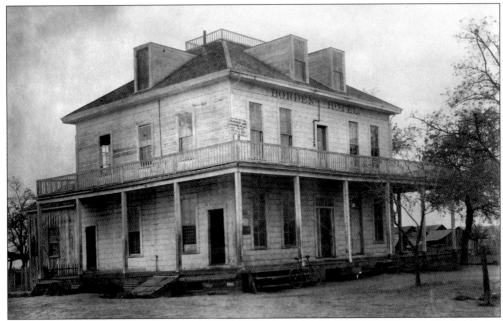

The Borden Hotel was constructed by Capt. Russell Perry Mace in 1874. Two years earlier, the Southern Pacific had laid its tracks south through the San Joaquin Valley, establishing railroad switches that then grew into towns. Borden was a thriving little community until the California Lumber Company laid out the town of Madera. Soon most of Borden's residents were moving to the more prosperous town four miles to the north. Captain Mace was one of these people. He sold the Borden Hotel and moved to Madera in 1876 to build his Yosemite Hotel.

The Russ House, shown in this c. 1890 photograph, was located on the corner of West Yosemite Avenue and G Street. It sat on the southern end of Chinatown and served a clientele that was distinctly of a lower socioeconomic status than those on the east side of the railroad tracks. The Russ House was razed to make way for Madera's first library building.

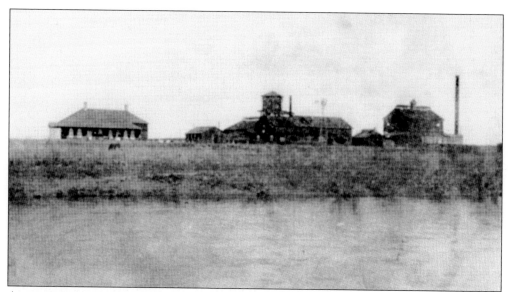

At one time, copper was a major export from Madera County. Most of the mines were situated near the town of Buchanan, 10 miles northeast of Madera. Some of the ore was brought to the Madera smelter, but most of it was shipped out by rail. By 1900, the price of copper had dropped so drastically that it became unprofitable to mine. For a while, boxing matches were held in the smelter.

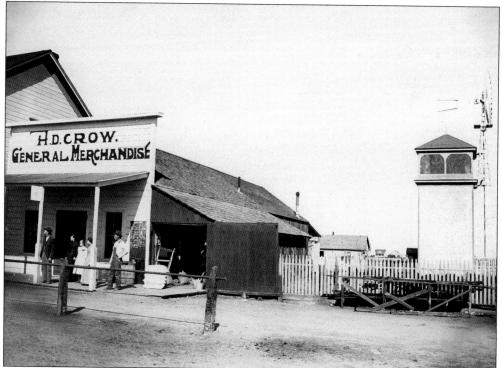

Herman Crow's merchandise store was located in Berenda, not far from the Vignolo Hotel. This store served the grain farmers who labored just to the north of Madera. Crow was a Madera County supervisor for a number of years and was a force to be reckoned with in local politics. He was also the grandfather of Guy Crow, one of the founders of the Madera County Historical Society.

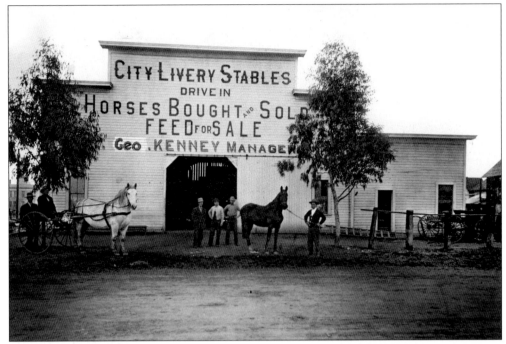

George Kenney's City Livery Stable was located on the corner of Yosemite Avenue and F Street, where the Yum Yum donut shop now stands. Pictured here *c.* 1885, from left to right, are James Vinson, Darwin Lewis Sr. (in the cart), Lisch Trengrove, George Coulter, Don McGowan, and George Kenny (holding the horse). Coulter was Kenney's father-in-law.

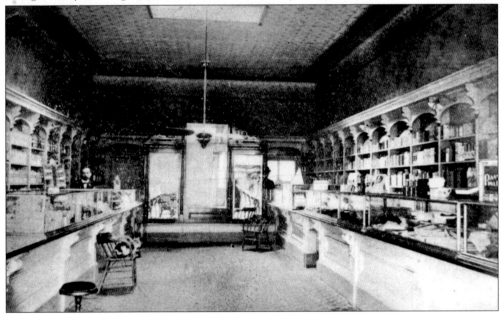

In 1890, the only drugstore in Madera belonged to William Wilken Wood Hunter. A primitive shop in its beginnings, Hunter's Drugs soon flourished and remained in business in the same location on Yosemite Avenue for over 100 years. The installation of a soda fountain inside the establishment was among the first changes made to the store as it began to take shape.

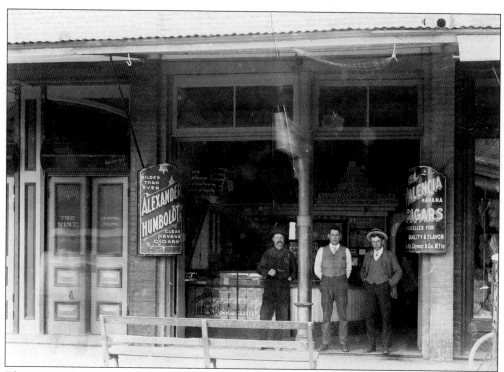

The Mint Saloon was owned by Sam Westfield. The man in the middle of this *c.* 1885 photograph is R. L. Bennett. Maderan Gene Baker is in possession of a pint bottle with the name "The Mint" blown into the glass. It is impossible to state with certainty just how many of these watering holes existed on Yosemite Avenue during the 19th century, but estimates vary from 12 to more than 20.

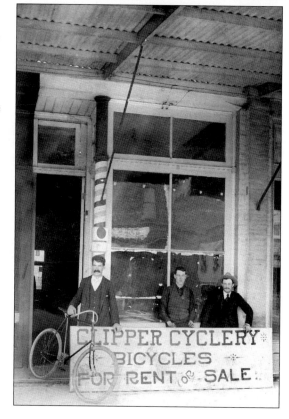

Madera had three bicycle shops during the 19th century. Clipper Cyclery was the first and most popular. Many Maderans used "wheels" for transportation, including the sheriff. Pictured *c.* 1890, from left to right, are Guy Hely, R. L. Bennett, and L. Lubrecht. One could get a bicycle repaired or buy a new one at the Clipper. They could also be rented.

Kirby's Cigar stand stood on Yosemite Avenue. It was the main competition for Payne's Cigar stand on the next block. Shown here, from left to right, are M. E. Kirby, the owner, and R. L. Bennett.

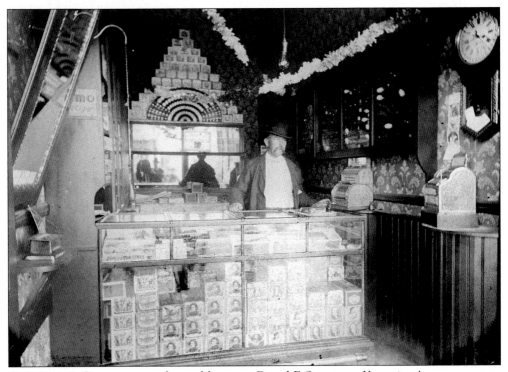

C. S. Payne's Cigar store was located between D and E Streets on Yosemite Avenue, next to Hunter's drugstore.

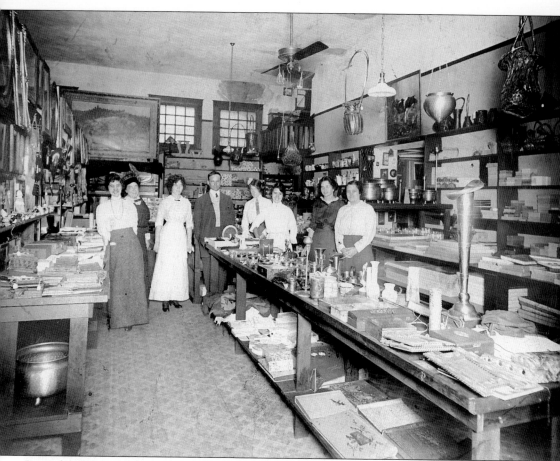

Preciado's Stationery store was established by Charles Preciado and his sisters Carmelita and Ida. Charles Preciado is pictured here in the center. The Preciados came to Madera in 1880 after a sojourn in Borden. Ygnacio, the patriarch of the family, left his native Hermosillo, Mexico, and came to the United States in 1849.

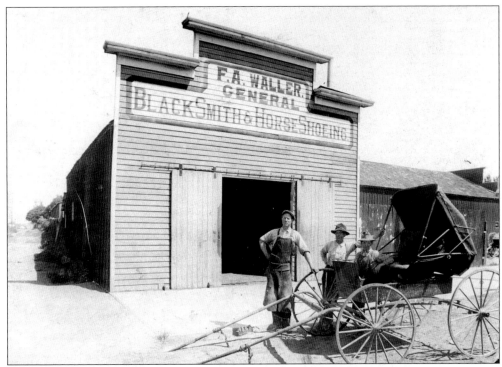

F. A. Waller had one of Madera's most successful blacksmith shops. The identity of the individuals in this *c.* 1885 photograph is unknown to the author.

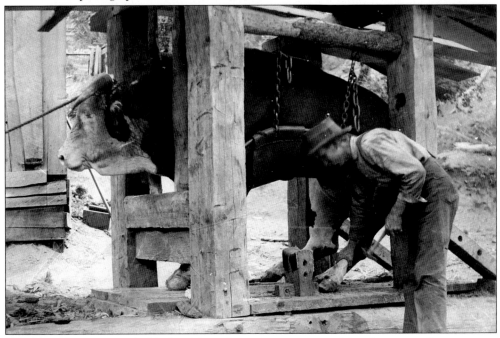

Obtaining the services of a blacksmith to shoe a horse was one thing, but persuading someone to shoe an ox was quite another. However, Reese Packard stood ready to do both. Shown here shoeing an ox, Packard has the animal securely fastened in this 1891 photograph.

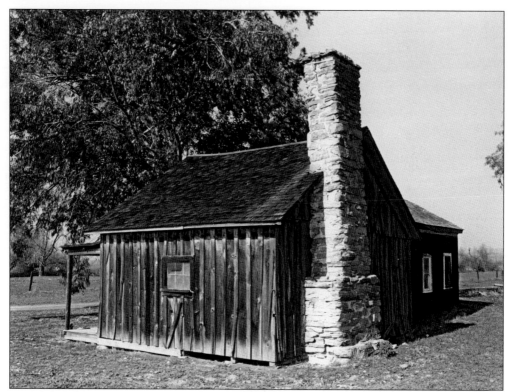

The Jerry Brown cabin, on the Wide Awake Ranch, is the oldest building in Madera County. Brown brought his wife to the area in the 1850s and erected this structure, which had the kitchen resting over the cistern. Just when they had established themselves in the cabin, Mrs. Brown fell through the kitchen floor into the cistern and drowned.

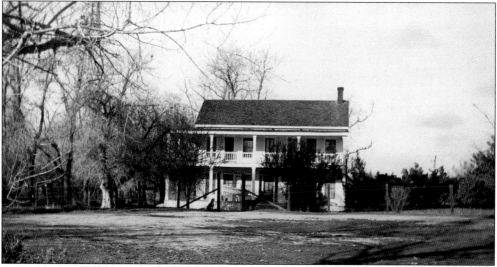

This building was constructed in 1864 by Emphrey Hildreth, Henry Clay Daulton, and Jonathon Rea. The three men were brothers-in-law who came west by covered wagon in 1853. This building was the home of 300-pound Emphrey Hildreth, who spent most of his days sitting in a rocking chair on the front porch. The ranch is now known as the Wide Awake Ranch.

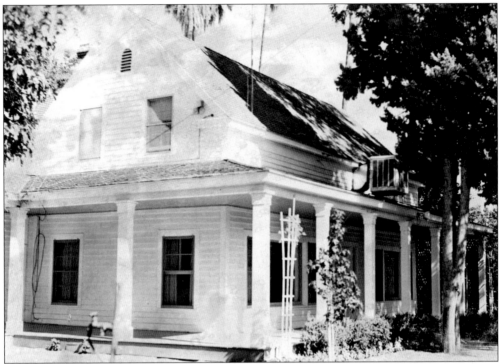

Henry Clay Daulton, with the help of his brothers-in-law, built this home in 1864. He christened the finished structure "Shepherd's Home." It was the center of Daulton's vast cattle and sheep operation. Daulton was Madera County's first chairman of the board of supervisors. On October 28, 1893, while returning to his home from Madera, Daulton was thrown from his buggy and dragged to death. The horse brought his mangled body up to this house and waited.

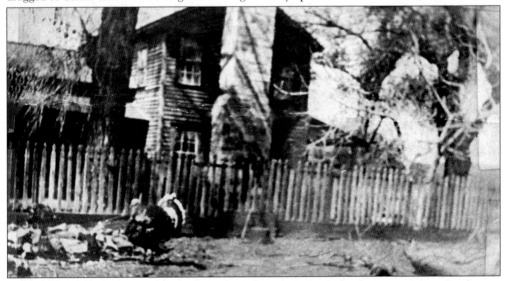

Jonathon Rea, like his brothers-in-law and with their help, built this home in 1864 in Buchanan Hollow. Rea was born in North Carolina and joined the Hildreth wagon train with Henry Clay Daulton. Rea gave Daulton his first band of sheep. The woolly creatures apparently were not Rea's only interest, as evidenced by the huge turkey in the foreground.

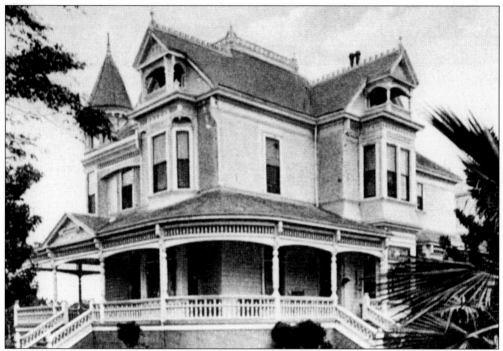

Pictured *c.* 1890, this home on North C Street was built by Return Roberts, Madera's lumber magnate. Roberts was a bank president and head of the Madera Flume and Trading Company. It was later acquired by Dr. Dow Ransom. In the 1950s, the *Madera Tribune* purchased the home and tore it down, announcing that it intended to construct a new newspaper building on the site. Alas, not one newspaper was ever printed there, and apartments now occupy the premises.

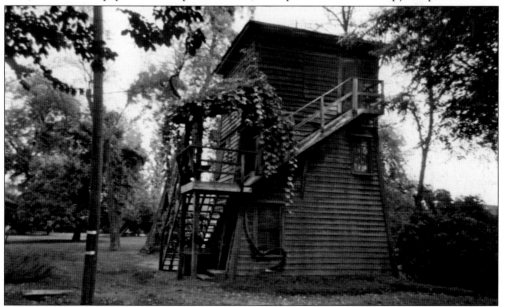

This tank house was built by George Washington Mordecai in the 1890s at "Refuge," his ranch four miles south of Madera. The tank house is just one of many of Mordecai's original buildings still standing; others are the bunk house, the blacksmith house, and the dairy building.

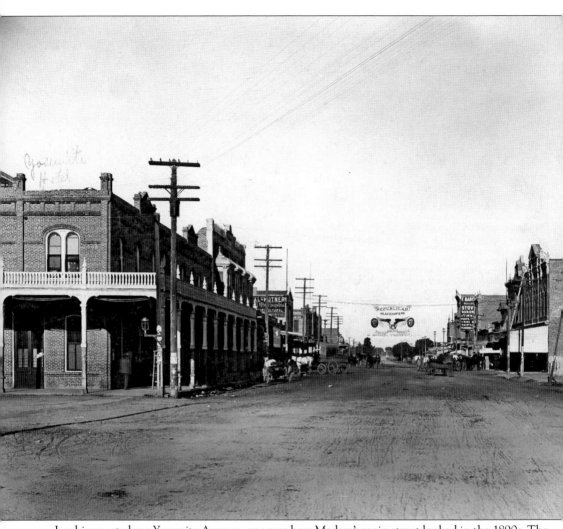

Looking east along Yosemite Avenue, one sees how Madera's main street looked in the 1890s. The banner across the street should not lead one to believe that Madera was a Republican stronghold. Actually, just the opposite was the case. Be that as it may, neither party was able to get the streets paved at the time.

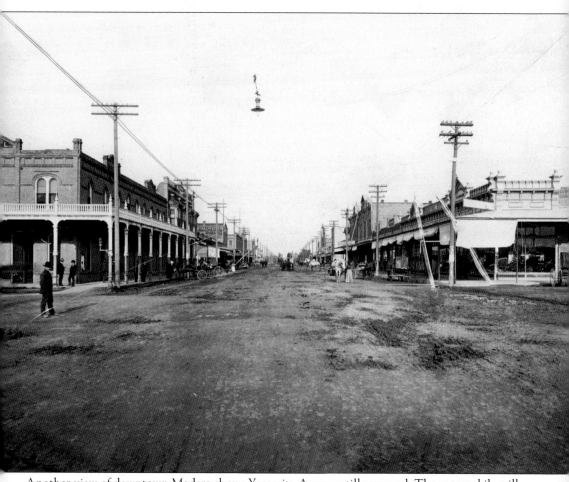

Another view of downtown Madera shows Yosemite Avenue still unpaved. The automobile still had not made its appearance in Madera.

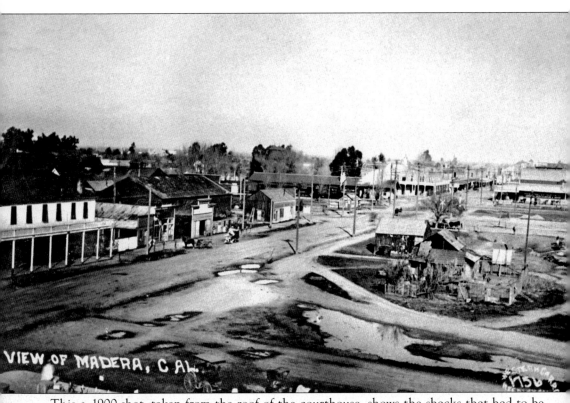

VIEW OF MADERA, CAL.

This *c.* 1900 shot, taken from the roof of the courthouse, shows the shacks that had to be eliminated before Courthouse Park could be laid out. There was considerable resistance from the owners, but this was overcome when an unexpected fire broke out one night and took the slums to the ground.

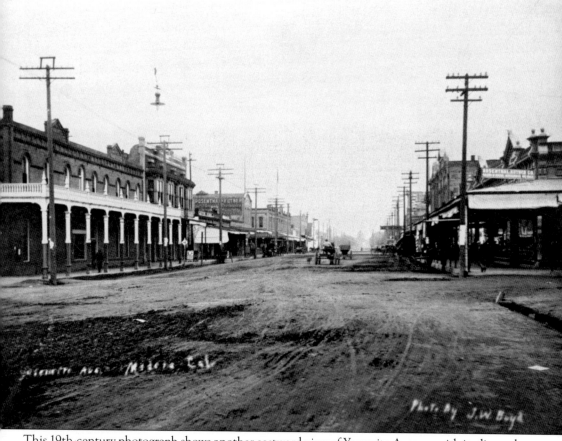

This 19th-century photograph shows another eastward view of Yosemite Avenue, with its dirt and dust. In the lower right, the Rosenthal-Kutner store corner can be seen. In the upper left, another Rosenthal-Kutner sign adorns the first Rosenthal Kutner store on the corner of Yosemite and D Street. The second floor of that building has been removed, and the ground floor is occupied by William Carol Clothing.

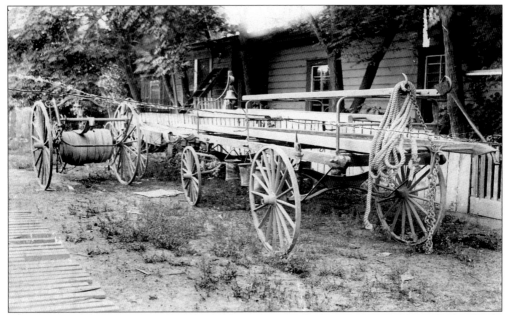

Early Madera had a first-class firefighting force, even with this equipment. In 1893, this hook-and-ladder outfit was state-of-the-art. It was gaudily painted and would accommodate 30 men, with 15 on each side. The hose cart was liberally trimmed with shining nickel. Its approach was announced by the ringing of the bell that hung from its handle. It carried about 500 feet of old-fashioned rubber-covered hose.

Madera's pioneer post office was located at 228 East Yosemite Avenue. In the window on the right of this c. 1890 photograph is L. O. Sharp, the postmaster in Madera from 1888 to 1894. The man at left is George Parsons, who was a postal clerk.

Madera's first jail, a wooden affair, is shown here *c.* 1885. Constable Herman Glas stands beside the building, which looks more like an outhouse than a jail. It was built with two-by-six planks, laid one atop one another, and then spiked down.

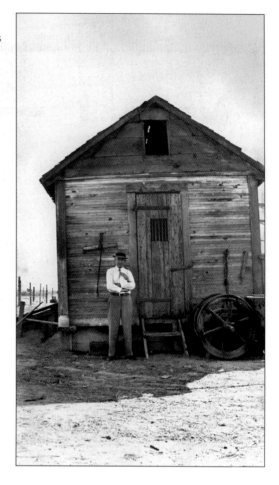

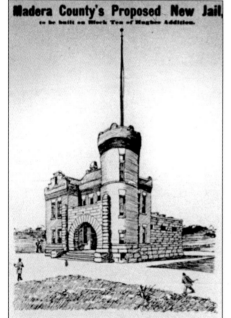

Madera County's Proposed New Jail,
to be built on Block Ten of Hughes Addition.

The above is a good picture of the plan for a new jail, selected by the Board of Supervisors, at the November session. It will be a handsome structure, built of brick and granite—mostly granite. It will be two stories high in the main and one-story in the rear or jail portion, but the jail portion will be so constructed that a second story can be added at any time it may be desired. The main building will contain the sheriff's office and sleeping apartments for the jailer. There will be seven cells in all as follows: Two large hobo cells, one cell for women, which will be of granite, a padded cell for insane patients, and three steel cells for criminals. There is also a room to be used as a kitchen. Upstairs there are several rooms, which will probably be used for sheriff or jailer's residence. A feature of the jail is that there will be only one entrance, and that through the sheriff's main office, which will prevent any communication with prisoners without the jailer's notice. Messrs. McDougal, the architects, claim that this handsome and substantial building can be built within the $12,000 limit, and to show their good faith will give a $5,000 bond to complete the building, provided no other bids are offered. The supervisors have advertised for bids which will be received and opened Tuesday, March 8, 1898, at 10 a. m.

In 1898, Maderans felt they were ready for a new jail, thus the authorities made this sketch public. It was designed to house the sheriff's office (as well as an apartment for the jailer), two large hobo cells (one for women and the other a padded cell for insane patients), and three steel cells for criminals.

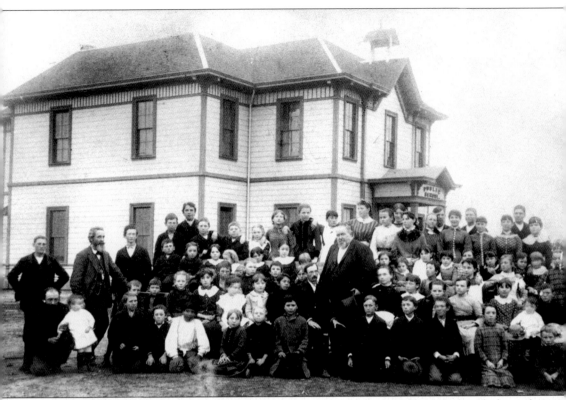

Pictured c. 1885, Captain Mace, Madera's first elected school board member, stands with the student body of Madera's first educational facility, Eastside School. This structure fell victim to a fire and was replaced with a brick edifice. The National Guard Armory is now located on the site.

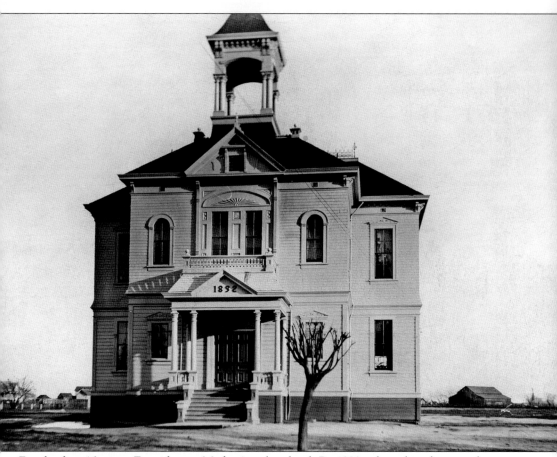

For the first 16 years, Eastside was Madera's only school. By 1892, when this photograph was taken, the town had grown to the extent that a second school became a necessity, so the citizens determined to build it west of the railroad tracks. It was a beautiful two-story structure, the naming of which did not strain the imagination of the citizenry, as it was called it Westside School.

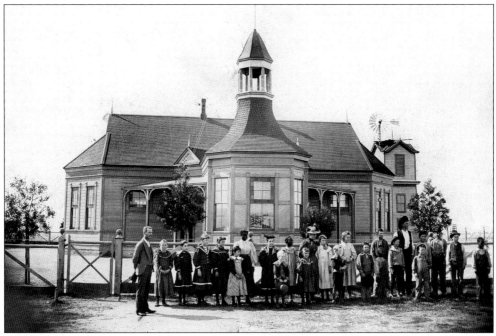

Among the schools that dotted the countryside around Madera was Berenda School. During the late 1890s, J. G. Smale, shown here *c.* 1895, was the teacher. Smale came to Madera County from Canada for health reasons and was hired to teach all grades at Berenda. He acquitted himself admirably and was highly praised by a tough school board, which included H. A. Buchenau, John Vignolo, and Henry Crow.

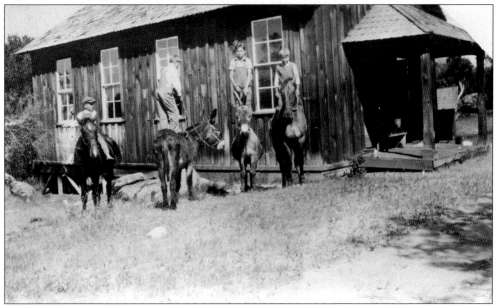

East of Madera was the Green School, which was located in the vicinity of the Black Hawk Lodge just off of present-day Highway 41. Most of the students walked to school, but at least four of them rode horses and mules. At recess, they often occupied themselves by playing with their animals, as this *c.* 1895 photograph clearly shows.

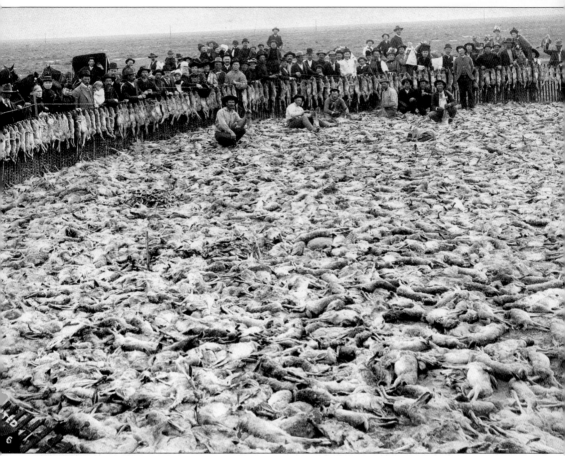

In the early days of Madera County agriculture, jackrabbits proved to be a formidable foe for the farmers, especially those who raised grapes. The entire community very willingly lent a hand to solve the rodent problem by holding periodic jackrabbit drives, like this one that took place c. 1890. The event started at the Mace Hotel, where the men and boys were given clubs and women brought their pots and pans. With these preparations complete, everyone headed for the country.

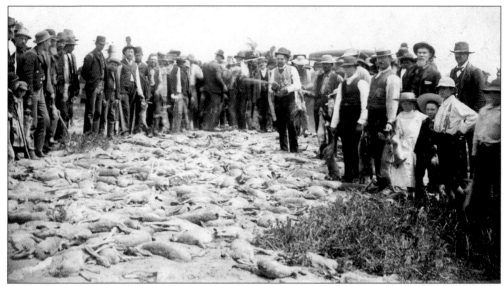

At the jackrabbit hunt, out ahead of the group were several men with a portable fence. At the prescribed time, women and children began to beat the pots and pans, driving the rabbits toward the makeshift fence. When the rabbits had been herded in the right direction, the men with the fence brought it around in a circle, trapping the quadrupeds. Then the teenagers took over. They climbed the fence and dispatched the rabbits with their clubs. The animals were then disposed of, and the crowd ate a picnic lunch.

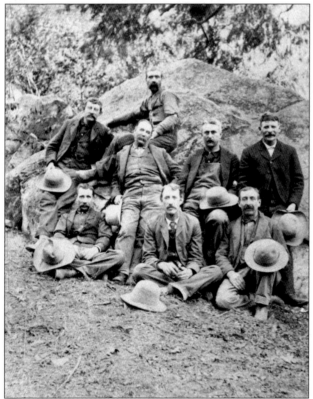

The Yosemite Stage and Turnpike Company, headed by Henry Washburn, operated stages from Madera to Yosemite and later from the town of Raymond to Yosemite. The drivers were a rough and ready bunch, by necessity. Not only did they face the perils of navigating the winding dirt roads to the mountains, they had to face the ever-present danger of meeting highwaymen along the way. Among the best of the drivers was Sam Owens, who is pictured here c. 1885, in the middle of the first row of drivers.

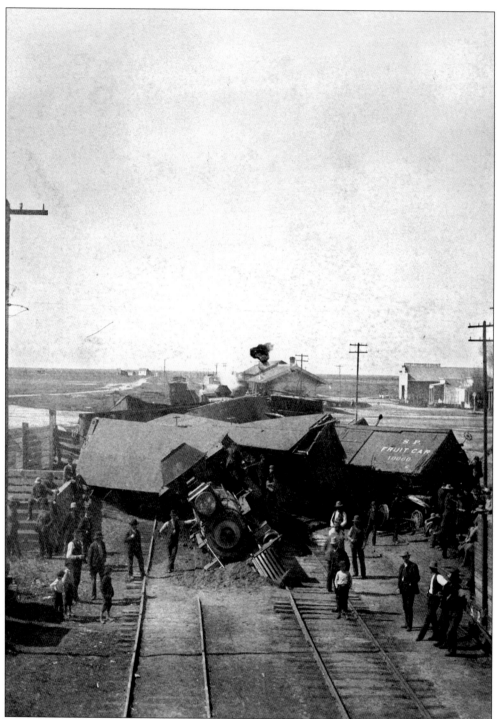

Stage-coach drivers were not the only providers of transportation who faced danger on a daily basis. Railroad engineers also dealt with their own perils, as this c. 1891 photograph clearly shows. This accident took place just south of Yosemite Avenue and F Street, near the Madera Flume and Trading lumber mill.

Jim Savage came to what is now Madera County in 1849. He operated a series of trading posts in partnership with Dr. Lewis Leach. In 1850, when his store on the Fresno River was attacked by Native Americans, Savage led a paramilitary group called the Mariposa Battalion in retaliation and in the process discovered Yosemite Valley. After the Indians had been pacified, Savage returned to his mercantile business. Unfortunately, he met an early and violent end on the Kings River on the morning of August 16, 1852, when he was shot and killed by Judge Walter H. Harvey. Savage's body was brought to the site of his Fresno River trading post and buried. His partner, Dr. Leach, arranged to have an obelisk of Connecticut granite brought around the Horn to mark Savage's grave. The building in these c. 1900 photographs, contrary to popular opinion, is not Savage's trading post. It was known as the China trading post, operated by Man Wah Chan.

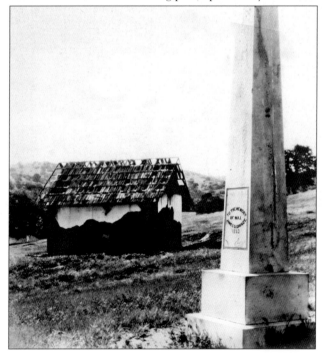

This *c.* 1895 shot of the Savage Monument is significant because the lumber flume that ran along the Fresno River can be seen in the background, showing the proximity of Savage's grave to the river. In the 1970s, Savage's body was disinterred by Ralph Baraldi and Alan Brown and moved to Buck Ridge in the Hidden Lake Recreation area. Oddly enough, among Savage's bones the men found a squirrel trap.

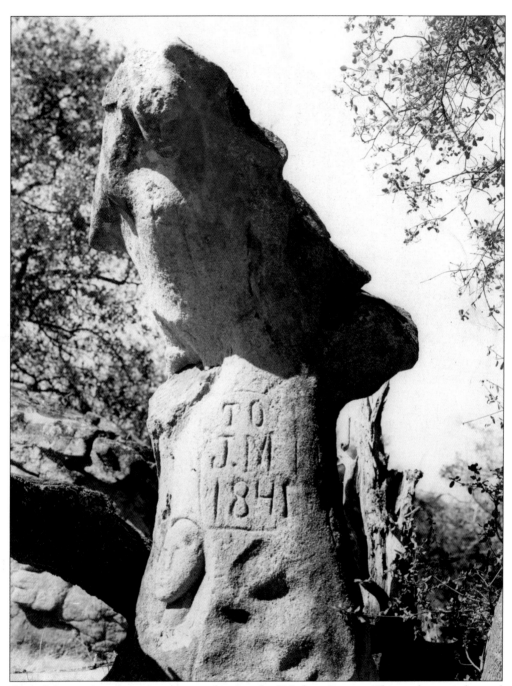

One of the area's greatest mysteries is the Angel of Madera County. This sculpture is located on the Brown Ranch, just off of Highway 41 and old-timers cannot remember a time when it was not in that spot. There has been much speculation as to who or what the "J. M." refers to, but some say it stands for Joaquin Murrietta, while others claim it stands for James Marshal. If 1841 signifies the date of completion of the monument, it was done when California was part of Mexico. One can clearly see the "angel" watching down from the top of the rock, while near the bottom, another face has been carved.

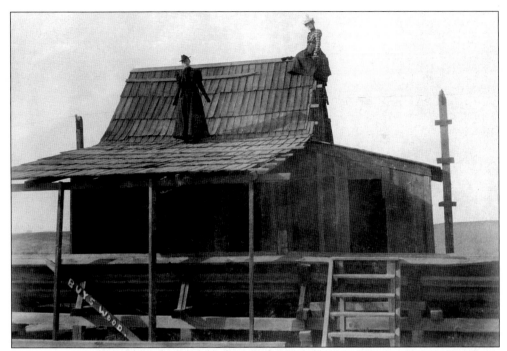

These two unidentified women went to a lot of trouble to get their picture taken on this flume tender's house, c. 1900. The flume tender who lived here, which was known as Six Mile House because it was six miles from Madera, had few visitors and presumably enjoyed the company on this particular day. The flume tender insured that nothing obstructed the lumber as it moved down the 56-mile flume to Madera, from an area near present-day Oakhurst.

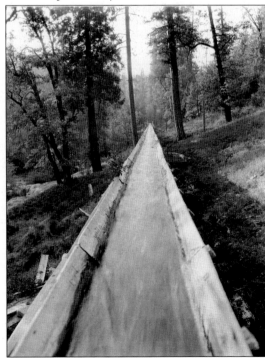

Although the flume was in need of repair at the time, water can be seen coursing its way down the giant water slide toward Madera. The first flume was built between 1874 and 1876 by the California Lumber Company. When it went bankrupt, the Madera Flume and Trading Company acquired its assets, including the flume. Later, the company folded and the flume fell into disrepair. In the late 1890s, the Madera Sugar Pine Company took over and rebuilt the flume.

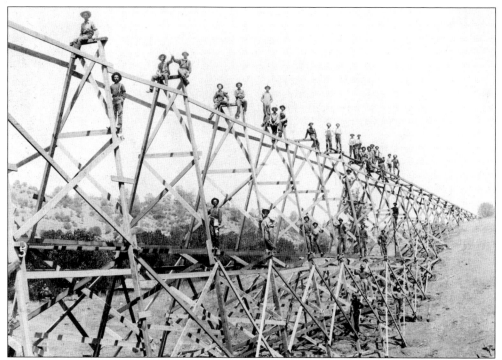

These rare, c. 1898 shots of flume construction show what a herculean task it was to build the 54-mile water slide. The trough traversed open, and often rugged, country far from roads during much of its journey. In many places, it literally clung to the sides of steep bluffs; at other points it tiptoed precariously across deep ravines on spindly trestles. In the foothills it sometimes twisted and turned its way along like a giant snake. The sides of the flume were made up of 1.5-inch by 16-inch boards cut in 16-foot boxes, braced securely on an arrangement of cross sills and stringers.

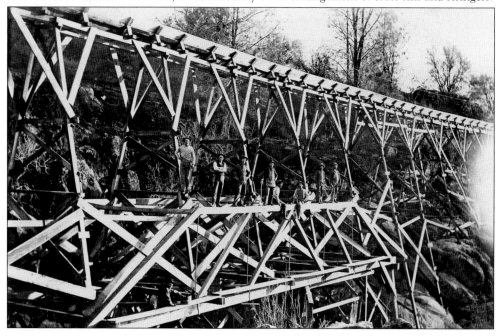

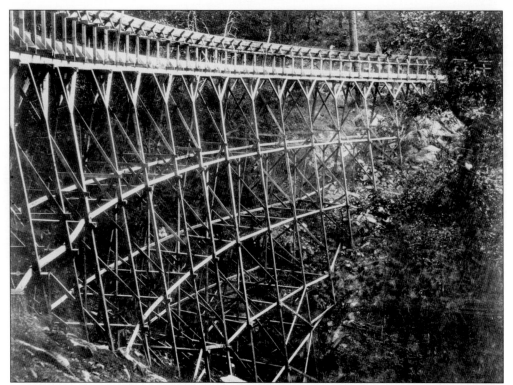

The flume is shown here *c.* 1898, crossing "Chew Grade," so named because the right-of-way passed over land leased by Ah Chew, a Chinese tenant farmer. The wooden V-trough spanned the deep ravine on a great 65-foot-high trestle.

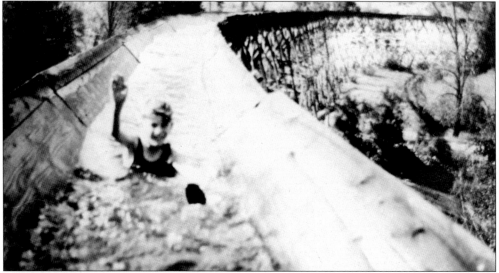

The flume obviously transported more than just lumber from the mountains to the valley. In this photograph, one young lad enjoys a trip that would surpass any amusement park log ride. At the end of a logging season, the flume tenders would load their gear on flume boats and ride the water down to Madera. There is one report of a cow that somehow got in the flume and rode a portion of the way down.

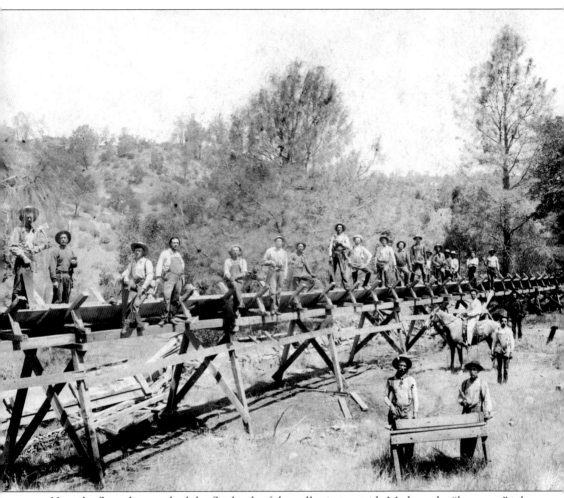

Here the flume has reached the flat lands of the valley just outside Madera; the "box crew" is busy repairing this part of the trough. This *c.* 1900 photograph was taken by Porter Thede, a Madera Sugar Pine Lumber Company boss.

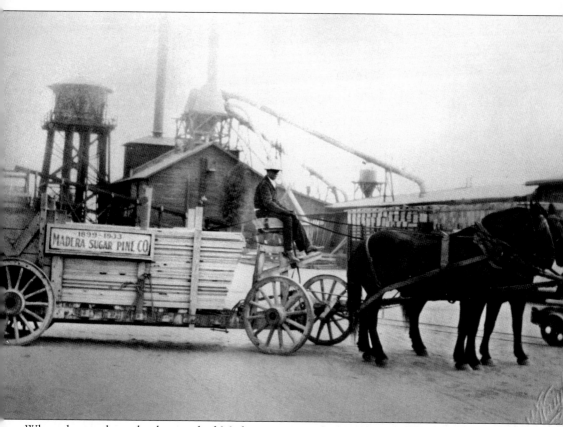

When the rough-cut lumber reached Madera, it was stacked and prepared for the fine cut that would turn it into planks ready for sale. This *c.* 1903 photograph shows the lumber industry of Madera at its zenith. The California Lumber Company had gone bankrupt, and its successor, the Madera Flume and Trading Company, folded as well. It remained for the Madera Sugar Pine Lumber Company to take the town into the 20th century and sustain it for 33 years.

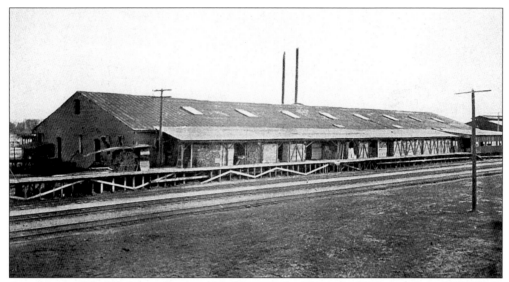

An adjunct of the lumber industry in Madera was the Thurman Sash and Door Mill. W. B. Thurman, son of William H. Thurman, gave up his job as sheriff of Madera County to go into this aspect of the lumber business. It prospered for more than a decade and a half.

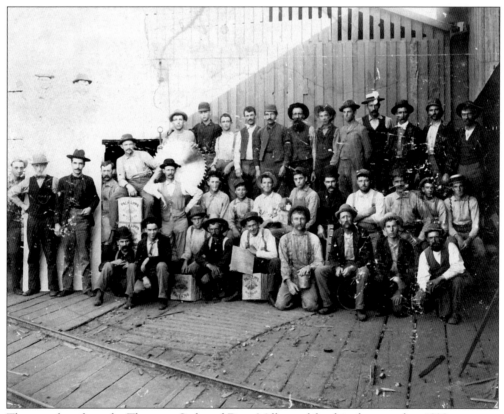

These workers from the Thurman Sash and Door Mill posed for this photograph *c.* 1898.

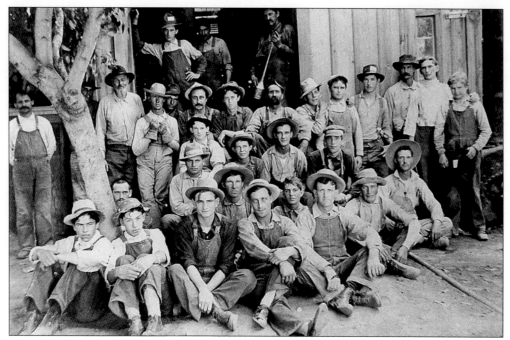

This group of mill workers was employed by the Madera Sugar Pine Lumber Company and posed at about the same time that the Thurman workers had their picture taken. Between both firms, most of the adult laborers of Madera made their living in the lumber industry.

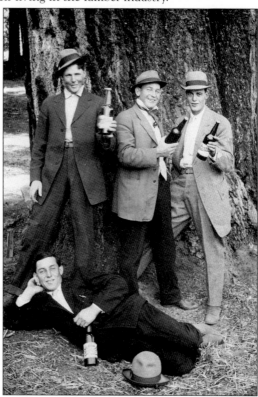

This group of lumberjacks got dressed up for a Sunday of revelry, c. 1900. Roy Stafford, one of the four Stafford brothers who worked for many years in the Sierra lumber camps, is lying on the ground. He died in the flu epidemic of 1919. Mill workers in the mountains had their choice of three bawdy houses to stay in, but many chose to reside in camp and attend the interdenominational church services there. Between paydays, the offering plates often contained poker chips that were later redeemed.

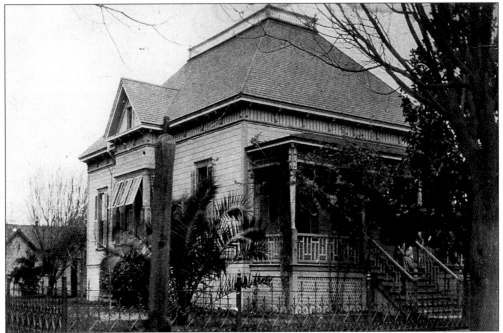

The E. H. Cox residence, situated on North C Street in Madera, was known as "the house that lumber built." Elmer Cox came to Madera in the 1880s and worked as a telegraph operator. By the turn of the century he was running the Madera Sugar Pine Lumber Company. The fact that the enterprise lasted so long was a tribute to Cox's leadership.

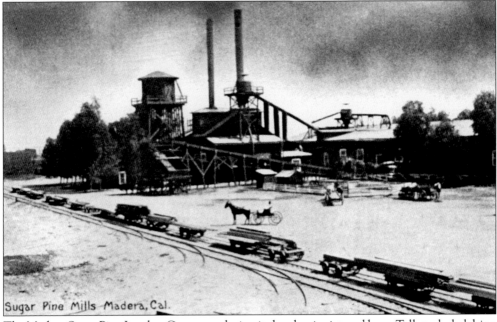

The Madera Sugar Pine Lumber Company, during its heyday, is pictured here. Tall stacks belching smoke, loads of lumber awaiting shipment on the railroad, and men coming and going to work characterize the scene. The importance of this concern for Madera cannot be overestimated. It saved the town from extinction.

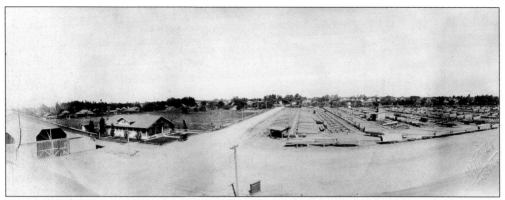

This c. 1900 panorama shows the Sugar Pine Lumber Company office on the left and a sizable portion of the lumber stock stacked up in the yards. If a person were to visit this site today, he or she would be at Madera Unified School District's Martin Luther King Middle School.

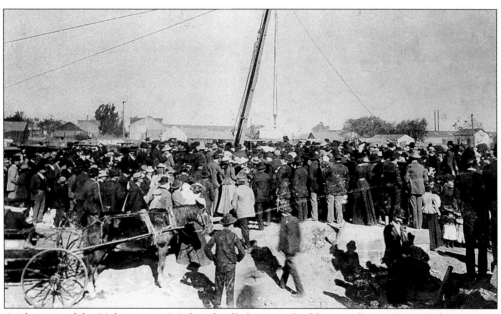

At the turn of the 20th century, Madera finally began to build a courthouse. Prior to that, county business was done at various offices on Yosemite Avenue. This c. 1900 photograph shows the crowd assembled for laying the cornerstone of the new courthouse. The building was constructed with granite brought down from Raymond. Among other things, the cornerstone contains a roll of Confederate money.

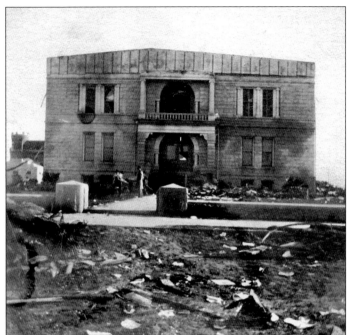

For two years, Maderans watched as pieces of granite were laid in place and their new courthouse began to take shape. The land on which the courthouse was built was given to the county by Thomas E. Hughes. Although he was known as the father of Fresno, it was in Hughes's best financial interest to promote Madera as well, since he was a major landowner there.

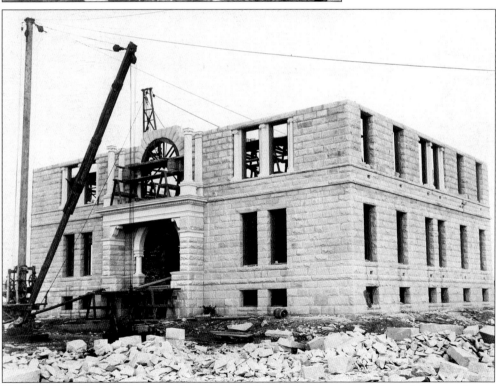

Huge blocks of Raymond granite dotted the landscape during construction of the courthouse (shown here and at the top of p. 57). Raymond granite was known throughout the United States, and the rock from this area was used to help rebuild San Francisco after the 1906 earthquake and fires.

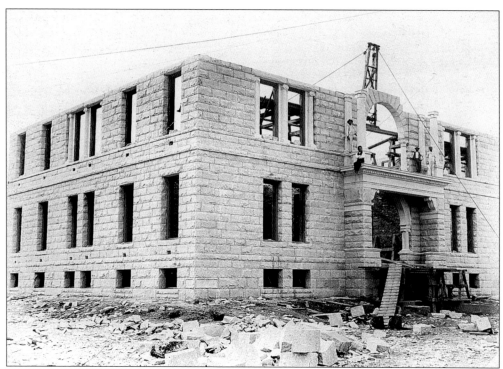

Raymond granite is also found in buildings in Sacramento, Los Angeles, Salt Lake, and Dallas, just to name a few. Maderans pointed with pride to the fact they didn't have to leave the county to obtain this popular building material.

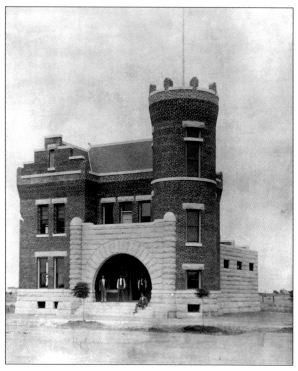

Madera County's beautiful new jail was built in 1888 and looked even more impressive when the granite courthouse was constructed on the same lot. One of the first inhabitants of the new jail was Leonard Hammond, who was charged with robbery. He was also the first to escape when he worked one of the bricks loose and hit Deputy Sheriff Ervine R. Lewis over the head and took his gun. As Hammond was leaving the jail, he met Sheriff W. B. Thurman and a fierce gun battle erupted on the front steps. The holdup man was able to nick the sheriff in the hand and escape. Shown in this c. 1900 photograph, from left to right, are Sheriff Thurman, Deputy Sheriff Lewis, and two unidentified men.

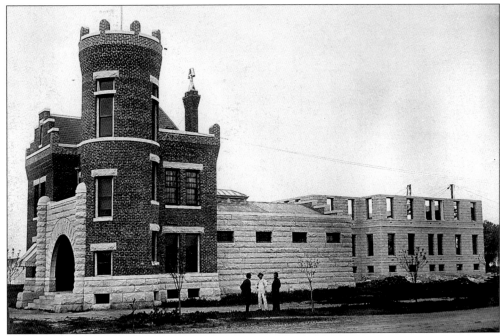

In this *c.* 1900 photograph, the courthouse is under construction behind the new jail. This area was considered "out in the country" at the time, although now it sits in a congested area between Highway 99 and the old Golden State Highway.

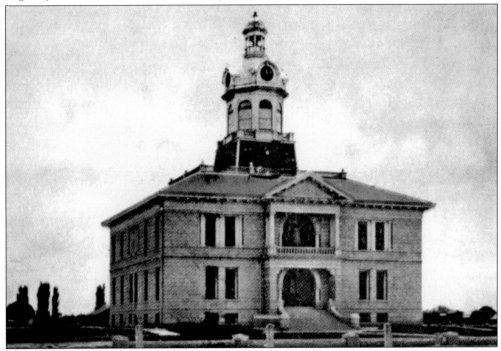

The newly finished courthouse building is shown in this *c.* 1901 photograph. Business commenced in 1902. Every county official, including the superior court judge, the treasurer, the tax collector, the county clerk, and the county assessor had an office in the courthouse.

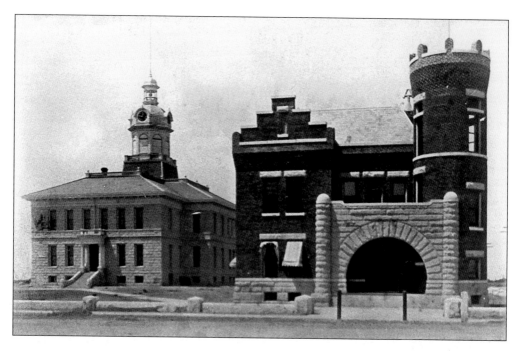

The new courthouse and jail were the pride of the county for a short while. Then disaster struck on Christmas Eve, 1906. Sometime in the afternoon of December 24, an arsonist broke into the courthouse and set a fire on the second story using kerosene and dirty rags. The granite, of course, did not burn, but the wooden furnishings did. The blaze brought the entire town out and made it nearly impossible for the firemen to fight the blaze. One county supervisor who insisted on directing the firefighting effort was punched in the jaw by a fireman.

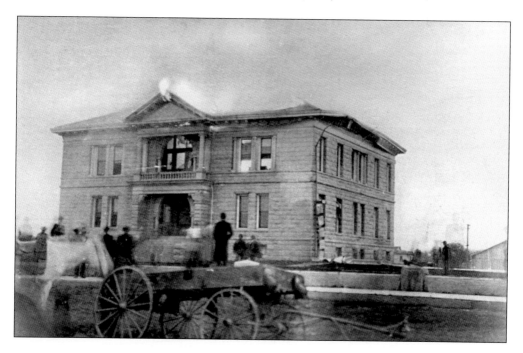

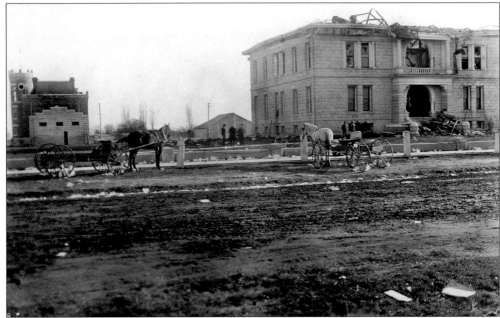

On Christmas morning, 1906, when Maderans normally would have been opening gifts, crowds streamed by to discover the new courthouse in ruins. The tower and large portions of the second story were gone. In their place, naked steel girders stood as a grim reminder that not everyone in town was civic-minded.

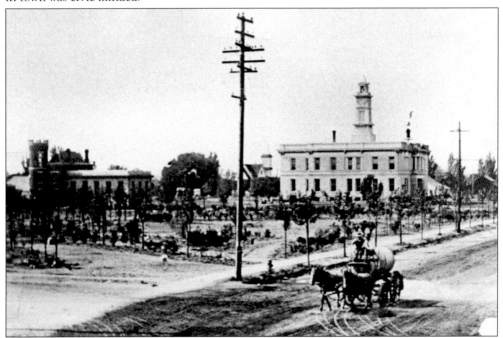

It did not take long to rebuild the courthouse and outfit it with a new clock tower. Nor did much time elapse before William King Heiskell laid out Courthouse Park. Some of these young striplings have matured and still provide shade for the numerous activities held there. The water wagon was in constant demand to keep down the dust, since Madera had no paved roads at the time.

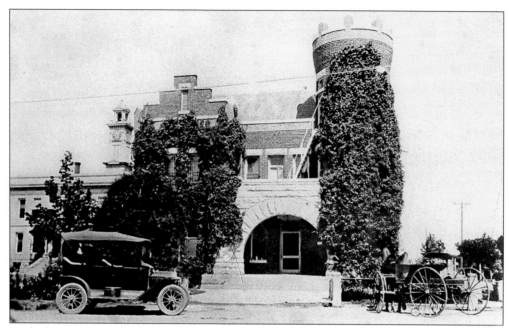

With the courthouse newly restored and a jail bedecked with ivy, Madera's law enforcement officers prepared to fight another enemy—bees. A chimney sweeper enraged a swarm as he was cleaning the flue and was soon covered with the insects. The man would most likely have died had it not been for the quick action of the jailer who turned the water hose on the bees.

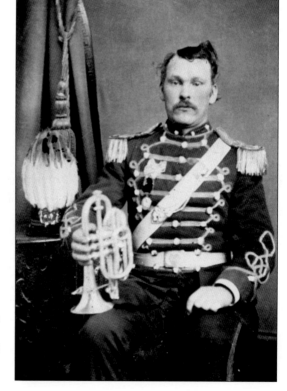

Richard Curtis Jay was born in Blazey, England, in 1853 and came to Madera in 1890. He and his wife, Anna, settled in the Hughes Addition, Madera's first subdivision. He immediately opened a furniture store, but his first love was music, having been a music teacher and a band leader before coming to California. He was for years the leader of the Madera band, a group of amateur musicians who played at community events.

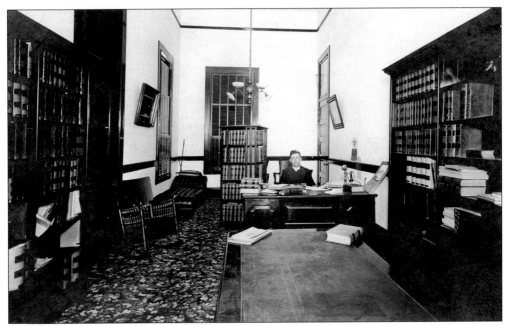

Superior court judge William Conley finally gets to sit in his chambers in the newly constructed courthouse. Conley was elected as Madera County's first superior court judge in 1893 but had to hold court up and down Yosemite Avenue until he had a permanent place to hang his robes.

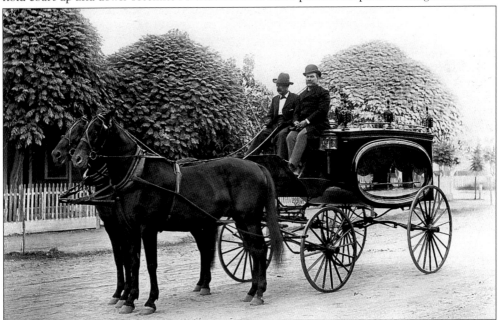

In 1893, Richard Curtis Jay made a coffin for an indigent woman who had died on the dole. The embalmer who was serving Madera at the time had refused to give the woman a funeral because she had no money. Jay stepped in and took care of the matter. The insensitivity of the embalmer prompted Jay to go into the funeral business, and he established Jay Chapel, which continues to operate. Shown here on the horse-drawn hearse is Jay (in the derby) and Cornelius Curtin, owner of Curtin's Livery Stable, at the reins.

Two

MADERA THE TOWN
1900–1920

During the first two decades of the 20th century, Madera outgrew its swaddling clothes and put on a new outfit, discarding the robes of a pioneer village and donning those of a pioneer town. As Maderans moved into the new century, they built a new courthouse and erected two new schools—one of them a high school. It began to pave its streets and built the town's first park, known forever after as Courthouse Park. The Madera Sugar Pine Lumber Company took over from the defunct Madera Flume and Trading Company and built a new flume. With new economic vigor, Madera waded into the new century.

The business section of Madera was still only three blocks long, but what a lively section of town it became. Yosemite Avenue remained the main street, but it choked the locals with dust in the summer and slopped mud on them in the winter. This was all put to rest in 1912, when Yosemite was paved.

There were several grocery stores in town. One of these was Rosenthal-Kutner, which occupied the southeast corner of Yosemite and E Street. Clerks there sold general merchandise as well as pocket-handkerchiefs and harnesses, in addition to food. Other grocery outlets were Franchi's, Rochdale, Wehrman-Meilike (with its nice little deli), Petty's, and Friedberger and Harder's. In addition to the grocery stores, Madera had two butcher shops in its downtown area. All of these businesses opened at 6:00 a.m. so housewives could order their groceries and have them delivered before noon.

Maderans, of course, did not have refrigeration—only an icebox, if they were lucky. Meat would not keep for long in summer, so children could often be seen riding their bicycles to Knowles or Barnett's butcher shop for a nice piece of round steak, for which they usually paid 25¢.

Lacy Robertson's saloon was on the corner of D Street and Yosemite and had an old-fashioned swinging door, just like the kind later shown later in movies. Rumor has it that at this time, the town had 14 saloons on Yosemite Avenue alone.

Madera had two banks on the same block. The First National was on the east end, and the Commercial Bank was on the opposite end in the 200 block. There were several Chinese restaurants, and Mugler's harness shop put out a display of its beautiful saddles and a barrel of buggy whips on the wooden sidewalk in front of their store. Of course, there were blacksmith shops to care for the shoeing of horses and repairing of farm equipment.

In addition to the Yosemite Hotel, the Russ House, the Southern Hotel, the Alta Hotel, and Madera's McCabe House stood right in the center of the business district. If one were downtown at just the right time in the morning, one could hear Vivian McCabe practicing her voices lessons from her parents' room in the building.

Cornelius Curtin had his livery stable on the northeast corner of Yosemite Avenue and C Street. The building took up over one-fourth of the block. Behind it was a white barn, with fences, and a corral, which was neatly kept. Mr. Curtin boarded horses and rented them out along with buggies.

Brammer's shoe store was just across the street from the post office. Mr. Brammer could often be seen standing in front of his store, greeting people as they went by. First he would give someone a smile and speak before staring at the person's shoes. Once he had a prospective customer inside, he rarely gave up without making a sale. Men's shoes brought $3 a pair, while women's footwear went for $2.50.

Preciado's was located where the Wells Fargo Bank now stands. It was a family store that sold sporting goods, papers, millinery, and stationery. There was also a nice ice cream parlor there with the homemade dessert ready for consumption. Further east on the same block was the Tighe and Breyfogle establishment, a department store with yardage, shoes, and clothing for men and women.

Hunter's drugstore, with its ice cream fountain, was a popular place, and some women would go there dressed up with gloves and hats on in the middle of the summer for a nice, tasty, frozen treat. Jay's undertaking parlor was located on the alley down from the Yosemite Hotel on the same side of the street.

The Madera Sugar Pine Lumber Company was located southeast of town. They had a large number of employees and many of them lived near Vineyard Avenue. The green lumber came down the flume, which in 1900 had been extended to 62 miles in length. The Sugar Pine Company had a downtown office in the old Curtin and Fleming building.

Madera had a skating rink on South D Street. It was on the top floor of a two-story building, and it swayed back and forth when it had a crowd in it. It was the practice rink for Madera's state-champion roller polo team.

All things considered, Madera during these first two decades of the 20th century was a grand place to live and work. People pulled together and pride in the town, with its short but vibrant history, made Maderans of a later time look back with envy at those halcyon days that could not last.

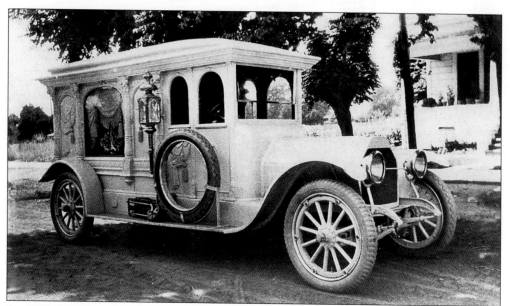

By 1915, Jay Chapel had put its horse-drawn hearse away and began to use this horseless carriage, a Studebaker hearse. The Jays gave it to the Madera High School for use in its driver-training program.

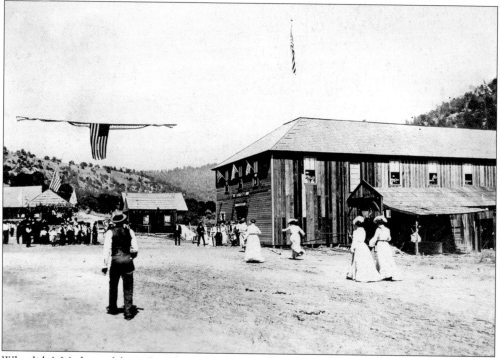

Why didn't Madera celebrate Fourth of July in 1903? No one seems to know the answer. Madera had been the county seat for a decade, and that in itself should have been cause for celebration. What is known is that Maderans flocked to the foothill town of Coarsegold to observe Independence Day, leaving the streets of their own hometown empty. Seen here c. 1903 is the crowd—made up of many Maderans—gathering for the festivities in Coarsegold.

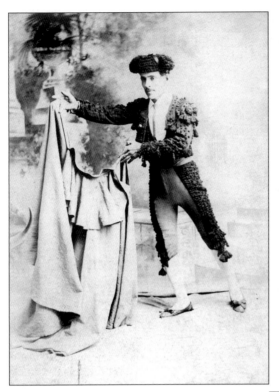

More than 2,500 people filled the makeshift stands on North E Street to watch Mexican matador Gonzalo Hernandez battle the bulls in Madera. Not only were the stands full, but people were perched on trees and neighboring rooftops to catch a glimpse of the bullfight arranged by the Madera Carnival Company to climax its four-day street festival in 1901. The curious fans, however, were unable to witness the bull being killed, for Sheriff W. B. Thurman stepped in at the last moment to halt the fight.

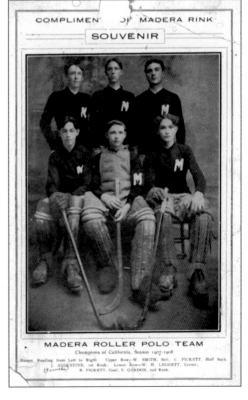

COMPLIMEN OF MADERA RINK

SOUVENIR

MADERA ROLLER POLO TEAM
Champions of California, Season 1907-1908

In 1908, Madera had a championship roller polo team. Looking none the worse after the rough ordeal they experienced at the hands of fans and players in Vallejo on April 27 of that year, the players posed for this photograph. Pictured, from left to right, are (first row) L. H. Leggett, E. Pickett, and Virgil Gordon; (back row) W. Smith, Clarence Pickett, and John Augustine.

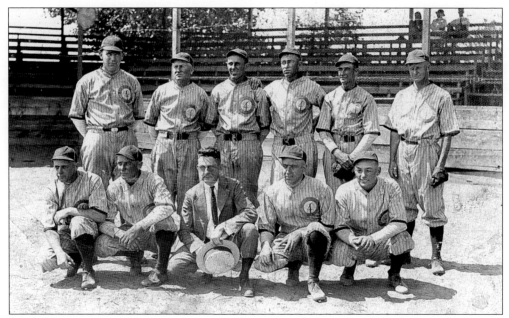

Baseball was an important community pastime in Madera during the early part of the 20th century, as this *c.* 1915 photograph taken at the local diamond illustrates. Maderans came out to support the Coyotes, their hometown team. The stadium stood where Swimming Pool Park is now located. Most of the time fun was had by all, but on Sunday, April 28, 1901, tragedy struck. As the team played against Berenda, Fred Kirkpatrick, Madera's shortstop, ran behind second base for a pop-up. He collided with the center fielder who was rushing in to catch the same fly ball. Kirkpatrick fell to the ground with a broken neck and died on the field.

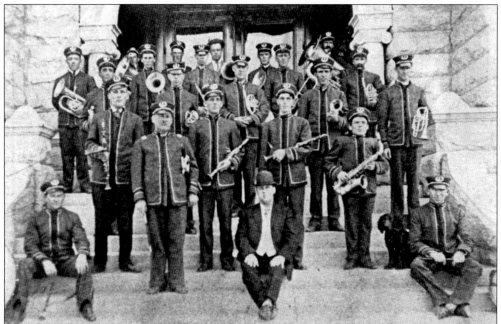

The Madera band played on Sundays in the park and at special functions. Shown here *c.* 1910 in their new uniforms, members of the band pose on the steps of the Madera County Courthouse.

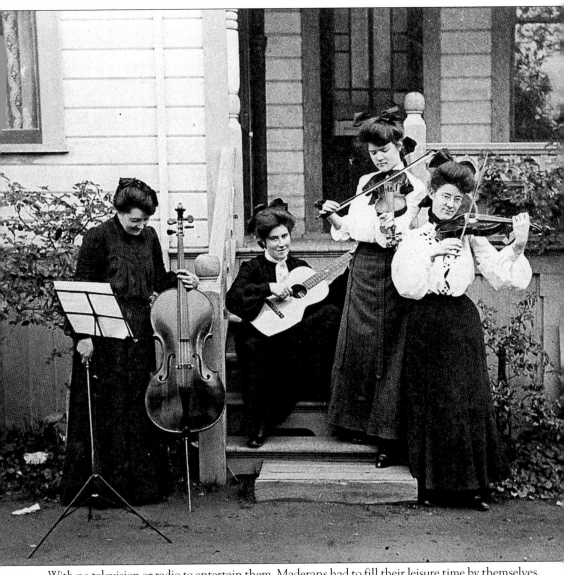

With no television or radio to entertain them, Maderans had to fill their leisure time by themselves. Here some local musicians play on the lawn of the Curen home on North C Street, *c.* 1910.

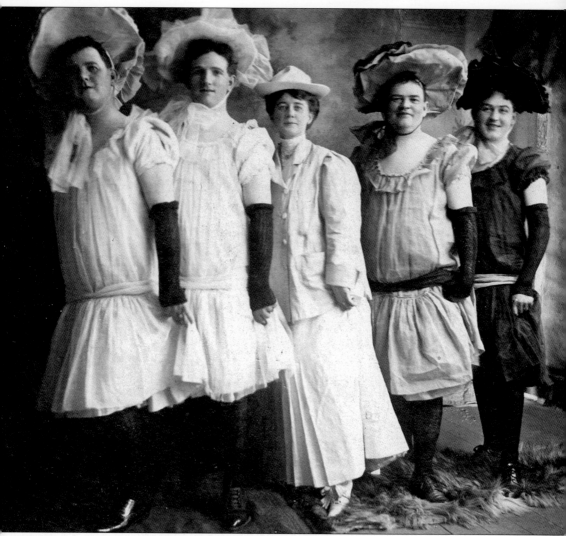

This group of prominent Maderans performed a comic opera for the Eagles Lodge in April 1907. The players, from left to right, included Russ Mace, Tim Williams, Inez Mace, Jack Smith, and Hershel Gordon. The Maces were children of Capt. Russell Perry Mace and his wife, Jennie. Inez went on to become a professional stage actress.

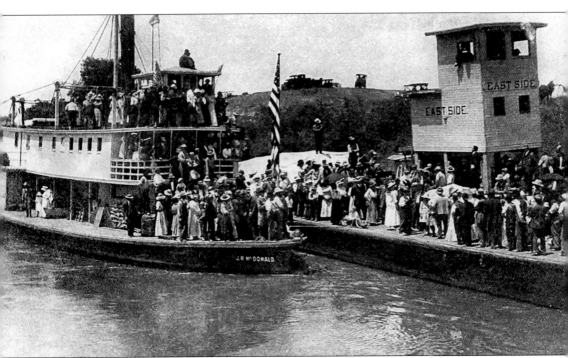

During the pioneer years of Fresno and Madera Counties, steamboats were used to bring supplies up the San Joaquin River to settlers moving into the valley. In 1911, a committee of residents from both counties enticed the owner of the *J. R. McDonald*, a paddle-wheel steamer, to travel the river again to show that it was still navigable. Though the trip was a success, the resumption of river traffic never became a reality. This photograph was taken at the Skaggs Bridge landing. The crowd on the dock is from Madera, while the ones on the boat are from Fresno.

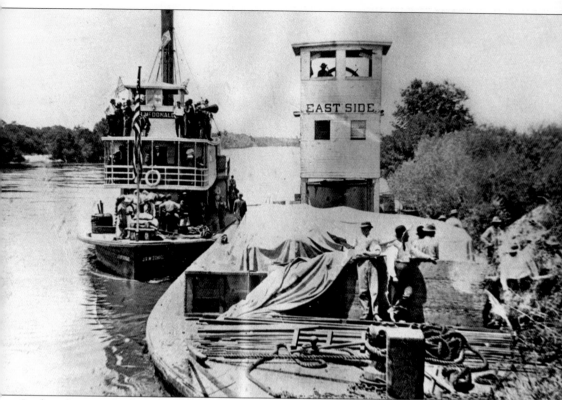

In this photograph, the *J. R. McDonald* has just arrived at the landing. The boat left Stockton on June 9, 1911, pulling a barge loaded with 123 tons of freight bound for Madera and Fresno. Just as it was pulling away, the ship's flag staff broke, so it was left in Stockton. When the vessel reached Mendota, the flag from the school house was pressed into service. The boat pulled into the Madera County landing on June 15, 1911.

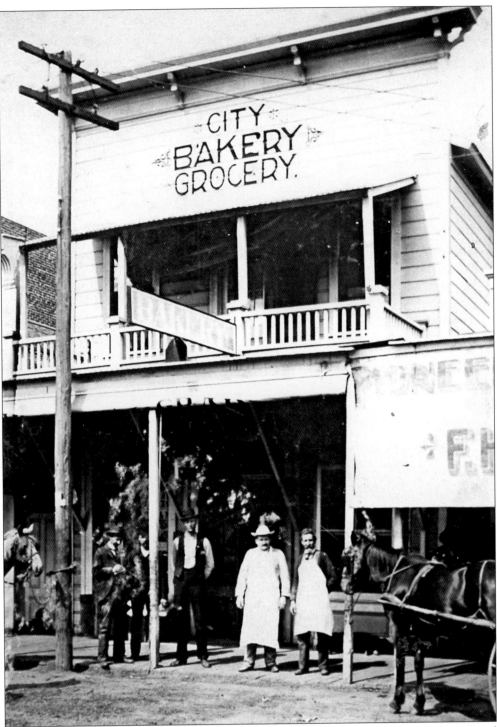

Stahl's City Bakery and Grocery finally found a permanent home between Yosemite Avenue and Fifth Streets, but it took some doing to get it there, as the next photograph illustrates.

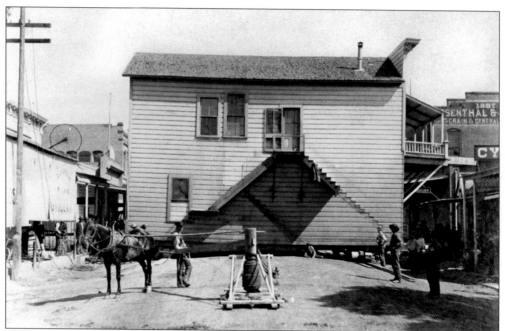

In the early days of the 20th century, one might see just about anything on Yosemite Avenue. Horse races, fist-fights, and street dances were common occurrences on the town's main street, but this scene was anything but common. Stahl's City Bakery and Grocery is being moved with a horse-powered wench to the middle of town. The year is 1906, and Albert Pen Hollow is the mover.

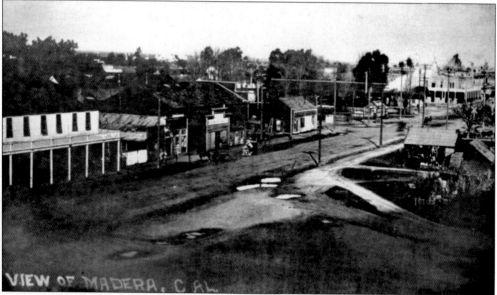

After construction of the courthouse and before courthouse park could be laid out, the shanties that occupied the area to the east of the building had to be removed. In 1909, the Madera County Supervisors entered into some heavy negotiations with the owners of the buildings, but the talks did not go well. The property owners and the county could not get together on a price. The dispute was settled on the night of June 5, 1909, when the shacks mysteriously caught fire. The next week, the landlords revisited their demands and settled the issue with the supervisors.

73

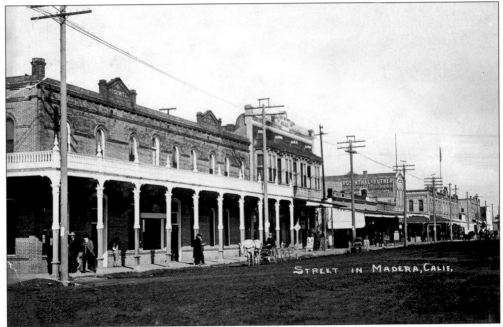

Here Yosemite Avenue is shown *c.* 1905 in its infancy. The view is from F Street, looking east and Mace's Hotel can be seen on the left. The main part of town at this time was only three blocks long, with a few businesses scattered on side streets. The unpaved avenue was dusty in the summer and full of chuckholes that played havoc with wagon wheels. In the winter, it was muddy and sloppy, and its sidewalks were made of uneven boards or just plain dirt.

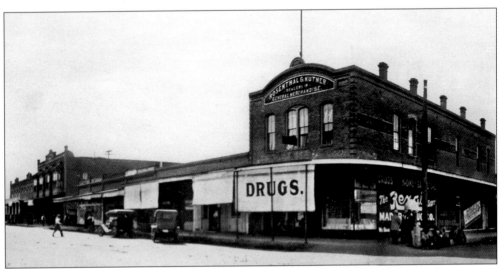

Some time after 1908, probably in 1910, this photograph, looking west on Yosemite Avenue, was taken. The viewer can see the first Rosenthal Kutner store, a two-story affair, on the corner of D Street and Yosemite. The top floor was occupied by Dr. Wing, an early Madera dentist. The Women's Christian Temperance Union water fountain, which had been constructed in 1908, is on the corner.

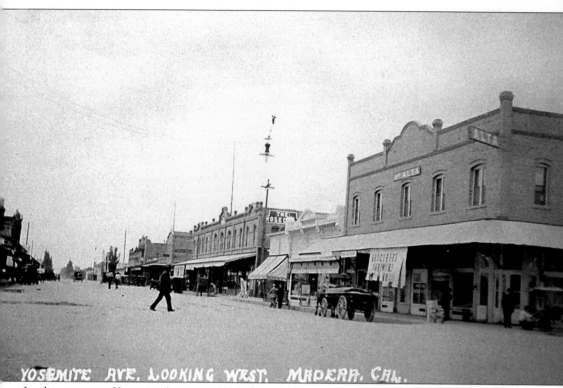

YOSEMITE AVE. LOOKING WEST. MADERA. CAL.

Looking west on Yosemite Avenue c. 1910, the Alta hotel is easily identified on the right (north side of the street). At this time, there were four hotels and several grocery stores in downtown Madera. Among the latter group were Franchi's, Rochdale, Wehrman-Meilike (with a popular deli), Petty's, and Friedberger and Harder's. Downtown Madera also supported two butcher shops.

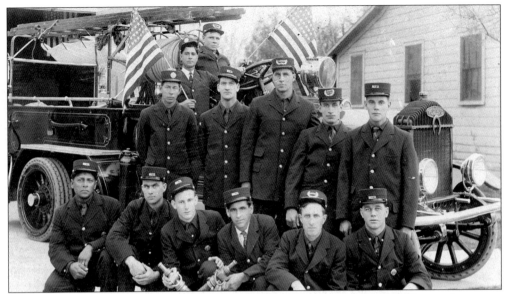

Madera's fire department was organized in 1885 and had only the most primitive equipment to use on the town's worst enemy. By 1915, however, things had improved, as this photograph shows. A fire engine committee was formed and decided to purchase a Moreland fire engine, which arrived on March 15, 1915. Joe Scott was appointed to be the driver and was given a stipend of $75 per month plus free rent, water, and sewer connections. It was a glorious day when Scott drove the Moreland up Yosemite Avenue at the fantastic speed of 30 miles per hour, on its first day in Madera.

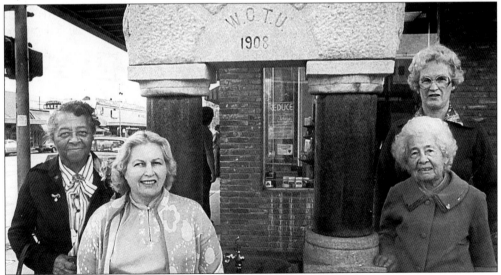

According to Madera pioneer Madge Cook, there were 14 saloons on Yosemite Avenue by the turn of the 20th century. To counter what they considered to be an evil influence, the Women's Christian Temperance Union organized a community drive to raise funds to build a water fountain on the northwest corner of Yosemite Avenue and D Streets. The funds came pouring in, and by 1908 thirsty Maderans had an alternative to the demon rum that was so prevalent on Yosemite. Ironically, during Prohibition, moonshiners often hid their contraband in the fountain's ice hold. This photograph was taken c. 1950.

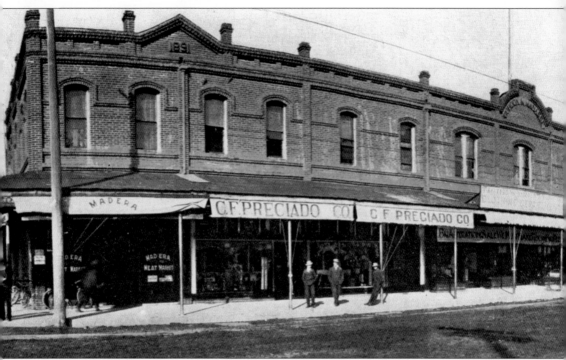

Pictured c. 1910, Charles F. Preciado's sundry store was located on the northeast corner of Yosemite Avenue and D Streets. Since he had abundant help from his sisters in running the establishment, Preciado found time to run for Madera County tax collector. In what can only be described as a personal tragedy, Charles was charged with embezzling county funds and tried three times. He was never convicted, due to a hung jury in each of his trials. Preciado suffered from epilepsy and was given to long periods of amnesia.

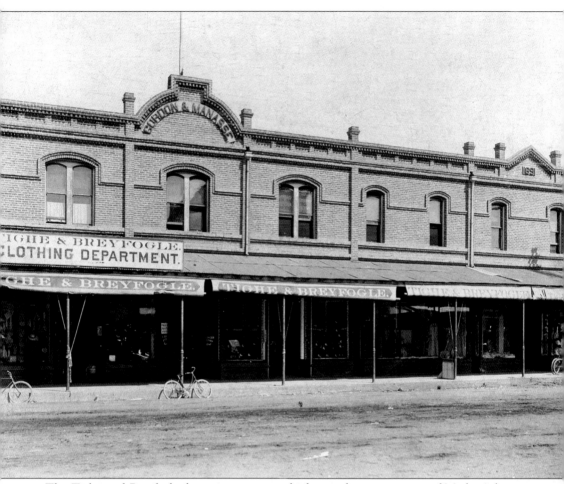

The Tighe and Breyfogle department store, which was the cornerstone of Madera's business community for years, had an inauspicious beginning. When its founder, William Tighe, came to town in 1891, he hopped off the train as it pulled into the local depot with just a few dollars in his pocket. It just so happened that at the time there was a store on East Yosemite Avenue owned by a man named Harris, who took a liking to the energetic young man and put him to work. Within a few months, Bill was a partner in the firm and he developed it into a city landmark. This photograph shows the exterior of the store, which was located on the north side of Yosemite Avenue, between D and C Streets. The Wells Fargo Bank is now located on the site.

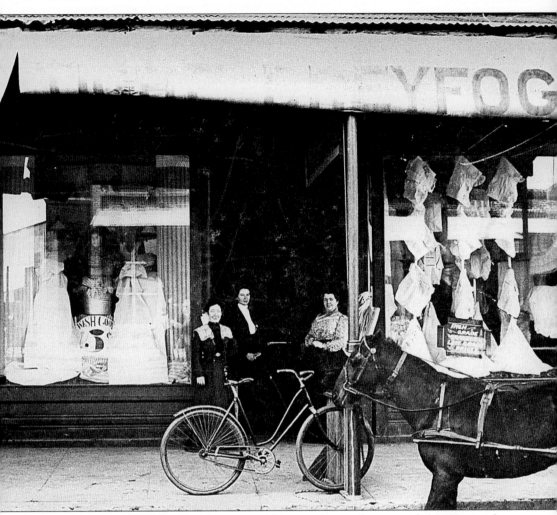

A short time after Bill Tighe went into partnership in a dry goods store with Mr. Harris, they bought out John Griffin, who ran a shoe store a little further up the street. This was a giant step toward success for Tighe, for by the time that Madera County was created in 1893, Bill was in complete control of the establishment and turned it into Madera's premier department store.

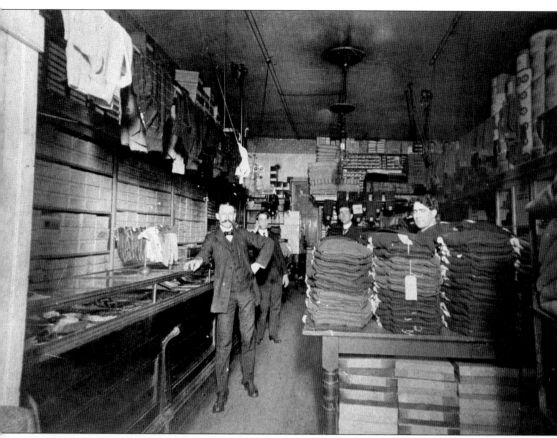

Pictured *c.* 1920 inside the men's department of Tighe and Breyfogle, Bill James Sr. can be seen in the center in the back of the store. Many of Madera's early citizens learned the clerking business under Bill's tutelage. Bill Griffin was his first employee when Tighe set out on his own in 1893. Young Griffin earned $25 per month for six 10-hour days. Other former Maderans, in addition to Bill James, who worked at the store were Wade Hampton, George Clapp, Annie Barnett Brown, Francis Merino Lareq, and Vic Merino.

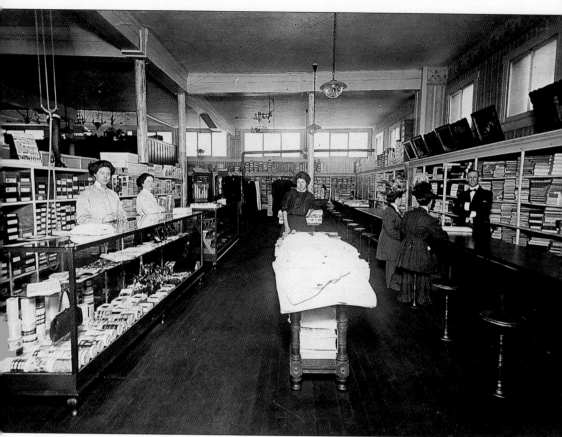

In this c. 1920 interior shot of Tighe and Breyfogle's, Bill Tighe can be seen on the right side. Just as his store was the center of the business community, so did the Tighe home at 204 North C Street become a center for community reminiscing. More often than not, Bill could be seen enjoying the passing scene from his comfortable rocking chair on the front porch. He was a part of Madera until his death in 1950.

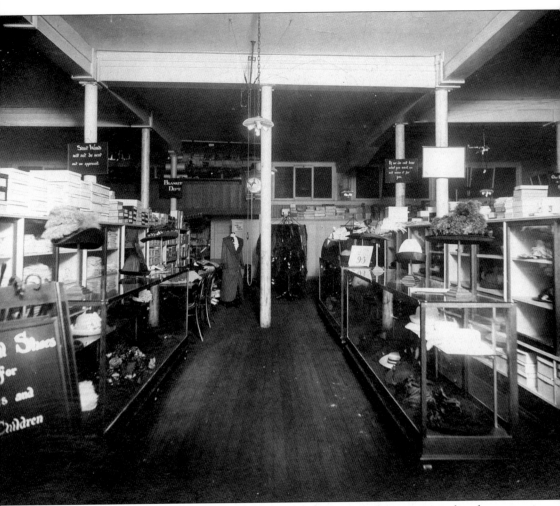

Tighe and Breyfogle used to advertise that if you couldn't find what you wanted at their store, it wasn't worth having. The assortment of shoes and hats shown in this c. 1920 photograph tends to give support to this claim. Much of the success of the Tighe Breyfogle department store has been attributed to Bill Tighe's own salesmanship and enterprise. He often conducted unique sales that brought in customers by the wagonload. One time, after he had suffered a fire, Bill advertised a "fire sale" that almost wiped out the entire stock of goods not damaged by the flames.

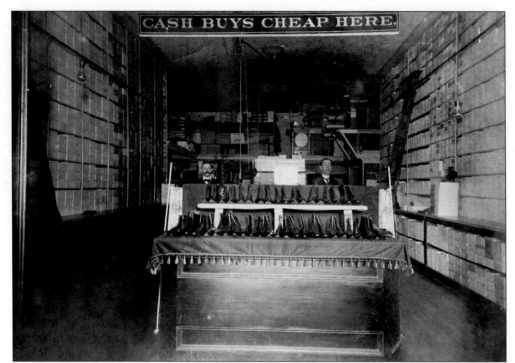

Brammer's shoe store was another pioneer establishment on Yosemite Avenue that bent with the times and survived. It began as a single-story, frame building on the north side of Yosemite Avenue. In 1913, owner Herman Brammer replaced the wooden structure with a single-story, brick building. About this time Herman brought his son, William, into the business, and in 1919 they expanded to a three-story, brick structure between D and C Streets on Yosemite.

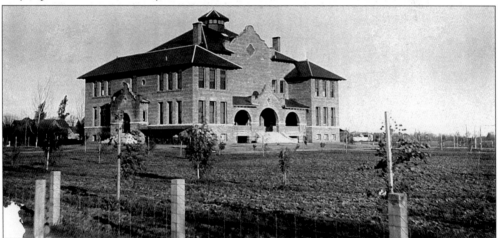

In 1893, the year in which Madera became a county, two very public-spirited women, Mrs. R. P. Mace and a Mrs. Wear, circulated a petition calling for an election to determine the public will in the matter of creating a high school in Madera. The voters and the new county government approved the plan with little debate, and Madera High School became a reality, although it had to spend the first 10 years of its existence in the second story of the old Westside Elementary School. In 1904, the student body of the high school moved into this new home, shown here at the time of its completion.

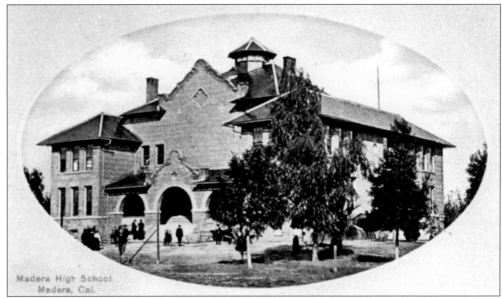

Madera High School
Madera, Cal.

With their new high school complete, Maderans set out to beautify the grounds by planting trees and shrubbery. This building lasted for just 13 years. On August 14, 1917, it caught fire and burned to the ground. The school board took the $7,000 insurance money and began construction again.

By 1915, Madera High School's graduating class had grown considerably. During its first eight years, the number of Madera High graduates seesawed between seven and three, starting in 1897 with seven and ending in 1904 with seven. Today Madera High School has 4,000 students.

The gender walls came tumbling down in Madera in 1918. The women shown here comprised the first all-female jury in Madera County. Charles Halstead was accused of grand larceny in Judge Conley's court. District Attorney Stanley Murray prosecuted the case, and Joseph Barcroft acted as counsel for the defense. After just three ballots, the women brought back a unanimous guilty verdict.

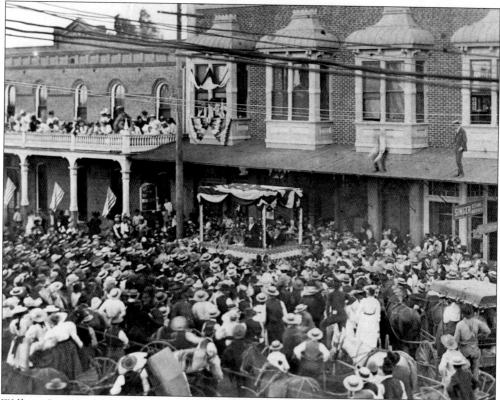

William Jennings Bryan, the golden-tongued orator and three-time Democratic candidate for president, drew a huge crowd in Madera during his 1906 campaign. The local Democratic club erected the speaker's stand in front of Mace's Yosemite Hotel, and people came from miles around to hear Bryan. The candidate's visit, which had been scheduled for just an hour, actually lasted almost half a day. The campaign train broke down, and another one had to be dispatched from Madera to take Bryan to his next stop.

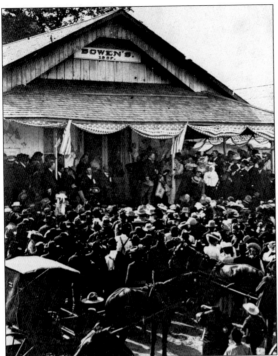

In 1903, Pres. Theodore Roosevelt passed through Madera County on his way to visit Yosemite Park and meet with John Muir. Roosevelt is pictured here addressing a crowd at Bowen's store in Raymond just before boarding a stage for Yosemite. On his return trip, Roosevelt thrilled a huge crowd at Berenda by speaking for more than an hour from the rear of the train. The president expressed his admiration for the industrious nature of Madera County residents and was himself presented with a commemorative plaque made of Sugar Pine by E. H. Cox of Madera.

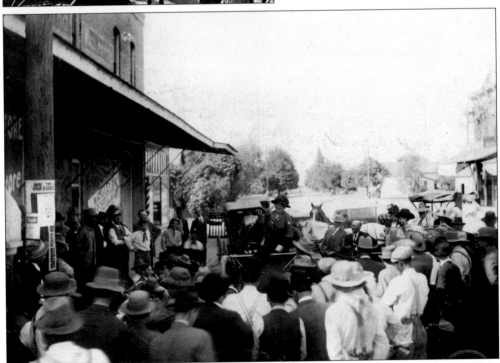

In the days before radio and television, Maderans were heavily involved in politics. Street rallies, campaign parties, and parades were just a few of the avenues of local political activity. In this c. 1912 photograph, Madera Democrats held a rally on D Street, just off of Yosemite Avenue, where the William Carol clothing store now stands. Note that the speaker is a woman.

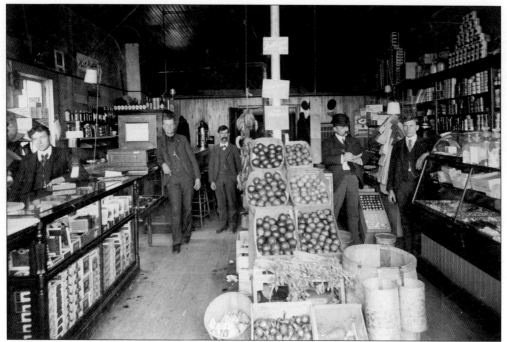

This unidentified grocery store on Yosemite Avenue provides a clear glimpse into what it was like for early Maderans to go shopping, although the individuals in this image seem to be more interested in taking inventory than in selling merchandise. Local grocers were supplied by nearby farmers as well as brokers who employed traveling salesmen to call on the store owners. Most of the canned goods and other items came by freight train to the Madera depot. Like most other businesses along the avenue, grocery stores also served as gathering places to relay neighborhood news.

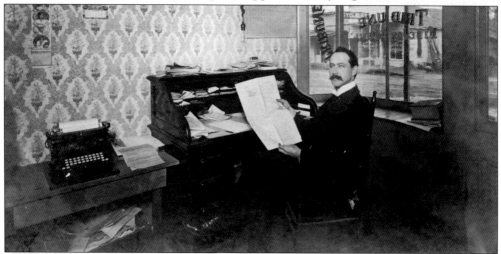

"He founded the *Madera Tribune* on March 31, 1892, and lived by the ethics of the Fourth Estate." These words make up the epitaph on the tombstone of the man shown in this photograph, George Clark, owner and publisher of the *Madera Tribune*. Clark's first office was on North E Street, facing the Southern Pacific Depot between Mace's Hotel and the San Joaquin Light and Power Company warehouse. Later, he moved to this office on D Street. In 1919, Clark brought his son, Howard A., into partnership. The two were copublishers of the *Tribune* until George's death.

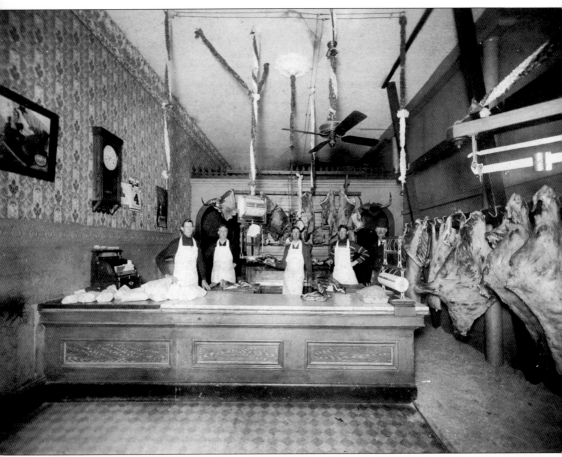

The Barnetts were among Madera's first families, having come here from Mariposa. One of them, John H. Barnett, served as Madera County sheriff from 1918 to 1928. He was one of the most colorful lawmen in Madera's history because of his attempts to stamp out prostitution and illegal liquor traffic. Before he was elected sheriff, Barnett worked in the family's butcher shop, which was located on the northeast corner of Yosemite and D Street. He is shown here c. 1905 with several members of the family. Pictured, from left to right, are Charley Swanson, John H. Barnett, Fred W. Barnett, Frank Floto Barnett, and owner John Robert Barnett.

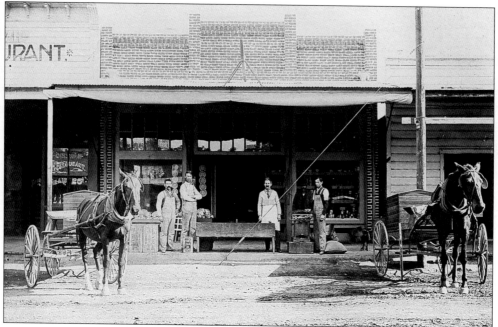

On May 14, 1916, Caroline Kegel made a fateful decision to visit this grocery store, Friedberger and Harder's, at 109 North D Street. After making her purchases she got in her buggy and headed back to her home near where the Schnoor Bridge now crosses the Fresno River. However, when she reached the railroad tracks on Central Avenue, she drove the horse directly in the path of a northbound train. Mrs. Kegel was thrown 60 feet and the next day at 8:30 a.m., she died. Such was the standing of the Kegel family in Madera that all high-school classes were canceled so that friends of her son, Francis Kegel, could attend the funeral. Among the group of mourners was nine-year-old Allen Harder, son of the grocer, who almost 80 years later still remembered that tragic day.

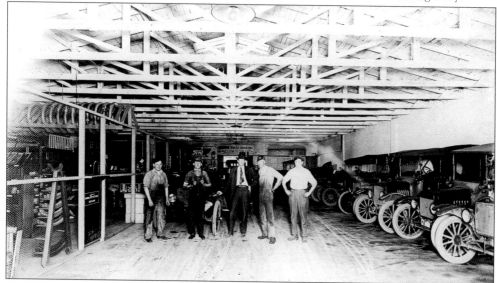

By 1920, there were enough automobiles in Madera to support this Ford Garage on South C Street; Virgil Gordon was the proprietor (center). It was a time of transition for Madera, during which horses and buggies competed with horseless carriages for the right-of-way on Yosemite Avenue.

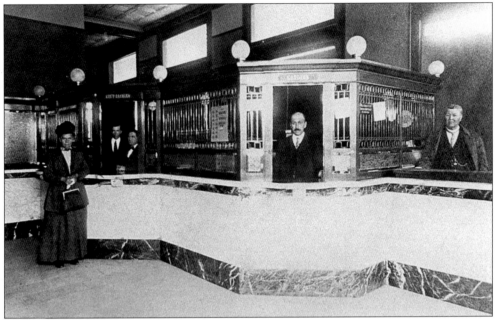

Madera's pioneer physicians, Dr. J. L. Butin (far right) and his wife, Dr. Mary Butin (far left), were directors of Madera's second financial institution, the First National Bank, located on Yosemite Avenue and C Street. In addition to tending to their patients, J. L. served as president of the bank, while Dr. Mary Butin functioned as the first female county health officer in the United States.

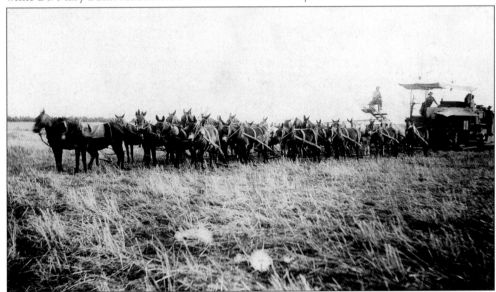

Agriculture in and around Madera first began with dry-wheat farming. This *c.* 1905 image was taken on the Ripperdan Ranch. George E. Ripperdan came to what is now Madera County in the 1880s and began to buy and lease land to farm wheat and barley. In 1887, he and his wife, Effie, established a home opposite H. Mochizuki's store. For 25 years, the Ripperdans lived there, farmed grain with mules, and raised eight children. At the time of this photograph, the area was known as the Ripperdan District. The Ripperdans sold out in 1910 and moved to Monterey. Pictured here are Al Hawkins, the driver; Fred Whisman, the sack sower; and J. W. Ripperdan.

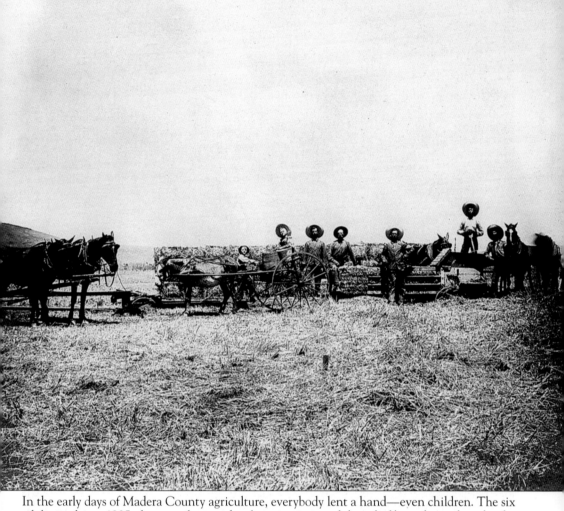

In the early days of Madera County agriculture, everybody lent a hand—even children. The six adults in this *c.* 1905 photograph were deeply appreciative of the relief brought to them by the young lad and his water wagon. The wide-brimmed sombreros worn by the men are not necessarily a reflection of any particular culture; every worker wore them to combat the intense sun of the San Joaquin Valley.

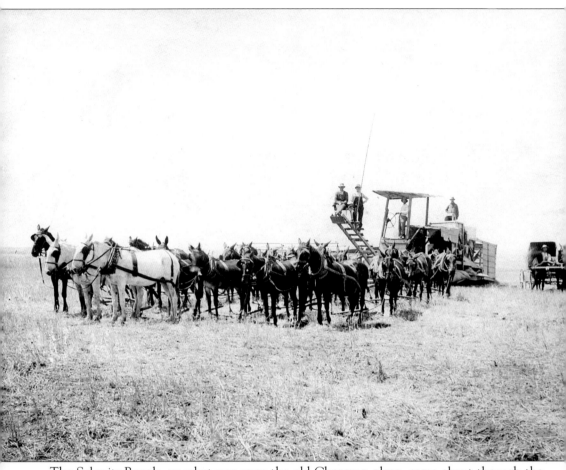

The Schmitz Ranch, on what was once the old Chapman place, came about through the industriousness of the first John Walter Schmitz, who obtained employment as a supervisor for Miller and Lux in 1871. At first, he was a fence builder but soon caught the eye of the cattle king because of his attention to detail and hard work. In a short time, Schmitz became the superintendent of Miller's entire Santa Rita Ranch. When Schmitz left Miller and Lux, he purchased the Chapman Ranch, which was located in the vicinity of the old Alpha School. By the time of his death in 1910, he had put together this huge ranch that was then operated by his son and grandson. In this c. 1908 photograph, taken before Schmitz's demise, are Frank Townsend (in the buggy), Chauncey Kast (driving the machine), Mike Pinkham (the header), and Ed Kline (the sack sower).

Three

MADERA THE CITY
1921 TO THE PRESENT

Like the nation of which it was a part, life in Madera during the 1920s can only be described as "roaring." Despite the efforts of lawmakers and law enforcers, the times were wild. Moonshine flowed freely, and prostitution, especially west of the Southern Pacific tracks, remained a visible part of life. As a result, Sheriff John Barnett emerged as the guardian of public morals, and proper Maderans hid behind his badge.

This was the decade that saw the demise of the Chinese community in Madera. Situated as it was in the area bordered by Yosemite Avenue on the south, Central Avenue on the north, G Street on the east, and I Street on the west, Madera's Chinatown was razed in 1923. This was also the year Madera lost Clarence Pickett, the city's first police officer to fall in the line of duty.

In the 1930s, Madera's lumber industry finally gave up the ghost. With the onset of the Depression, the Madera Sugar Pine Lumber Company shut down in 1933. For the first time, Madera was not supported by the industry that gave the city its birth. Now the foundation of its economy became agriculture.

During the 1930s, the source of Madera's farm labor came from the dust-bowl migration, in contrast to the Mexican workers who came in increasing numbers from 1940 to the present. Children from Oklahoma, Texas, and Arkansas filled the country schools and made up the bulk of the recipients of "migrant education."

Unfortunately, difficult times brought conflict, as they often do, and in 1938 the struggle between laborers and farmers reached the boiling point. Maderans witnessed several clashes between the two groups, and scores filled the county jail. In time, the crisis itself dissipated, but the cause of the problem remained. Economic uncertainty exposed the raw nerves of everyone.

Hard times did not, however, keep Maderans from celebrating the good things of life. The Old Timers' Day Parade, which had been initiated in 1931, continued to roll down Yosemite Avenue every October, attracting thousands along the way.

Madera took another step toward modernity in the 1930s when the first airmail delivery from the city took place at the local airstrip. The bundle of mail was given to the pilot, who then flew it to Fresno's Chandler Field for further distribution. The letters on this first airmail run came to the airstrip from the newly constructed post office on Sixth and D Streets.

93

The 1940s began with the burning of the Madera Theatre. Despite the heroic efforts of firefighters under the direction of Joe Cappelutti, Madera's first fighter was lost in the line of duty. In characteristic fashion, however, Madera bounced back, and on September 5, 1941, the new Madera Theater opened to a crowd of over 1,300 viewers.

Three months later, America went to war, and so did Madera. As they had done in World War I, scores of young men and women left the community to defend their country. Many never returned, and their memory is preserved in the War Memorial at Courthouse Park. War in Korea touched Madera during the 1950s, and as in previous conflicts, Maderans responded to the call to arms. Once again, many of the city's young people made the supreme sacrifice to keep their homeland free.

This was a time for relatively rapid expansion, and with that came a number of new schools. Presidents Thomas Jefferson, James Monroe, James Madison, and John Adams were honored by having campuses named after them. Millview School paid homage to Madera's lumber history, and Sierra Vista was so named for the perfect view it had of the Sierra Nevada Mountains.

The storm of armed conflict in distant lands once more drew Madera into its vortex, and again Madera lost some of its precious young, this time in the rice paddies of Vietnam. One jet fighter was christened the *City of Madera*, and its crew symbolically carried the town with them in the skies over Vietnam.

Throughout the remainder of the 20th century, the city of Madera has continued to grow. At the present time, its population is nearing 50,000 residents. New industries have made their appearances, and a new county government center is being constructed.

In the midst of this phenomenal growth, significant changes have taken place in Madera, especially along the main street of Yosemite Avenue. The city's founding fathers would never recognize the boulevard they drove their buggies and Tin Lizzies down years ago. Old-time families no longer come to town to shop and gossip, for they patronize stores in the outlying shopping centers. In their place has come a generation of newcomer residents who are within walking distance of downtown Madera.

In a sense, one can say Madera has been made over. It will never be the compact village or bustling small town that it once was. It is now a diversified city, and while one can never be certain of the future, the past is secure. To share the memory of Madera "as we were" will pay rich dividends. Hopefully this book will be a catalyst for that effort.

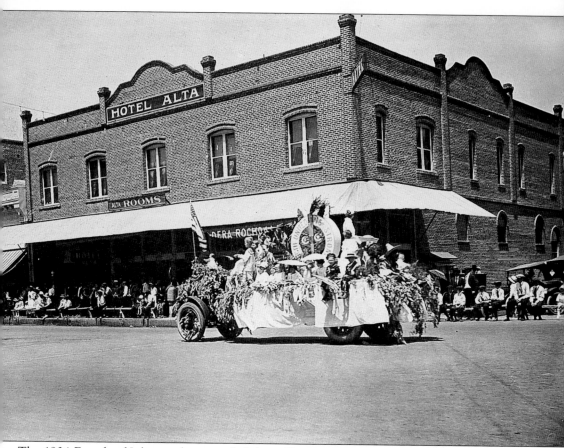

The 1904 Fourth of July parade proceeded down Yosemite Avenue and, as this photograph shows, passed the Alta Hotel on C Street. The day stood in sharp contrast to the Fourth of July celebration of 1903, when deserted streets gave mute testimony to the fact that Madera did not officially observe Independence Day with its usual celebration. Such was the chagrin of the business community that in 1904 Madera's Fourth of July celebration was so elaborate it drew visitors from all over. Floats and bands came from Fresno, Merced, and Modesto. William M. Hughes was the parade marshal and seats were set up along Yosemite Avenue with ice-water barrels liberally distributed for the comfort of the onlookers. After the parade, there were the usual Fourth of July activities, complete with orations, patriotic music, and fireworks. Madera had learned a lesson—nature abhors a vacuum. Never again would it let Independence Day go by without a proper observance.

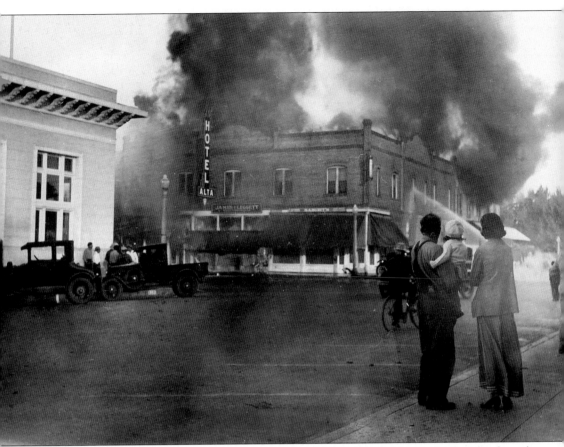

On September 27, 1931, at 6:00 a.m., Miss Nellie McSweeney, a Madera High School teacher, frantically threw open the window to her room in the Alta Hotel and began to yell; the building was on fire. Chief John Brammer, who was directing fire-fighting efforts, was the first to see the imperiled teacher. He shouted to fire captain Joseph Cappulutti, who was on the roof and made his way carefully to McSweeney's window. Cappulutti pulled the teacher from her smoke-filled room while the assembled crowd stood spellbound. A moment later, Nellie was safe on the street and away from the fire. The conflagration had been started by faulty wiring in a storeroom. The Alta Hotel fire was finally contained within its four walls without spreading to other buildings on Yosemite Avenue, but the $200,000 cost was staggering for the times. Luckily, no life was lost, which can be attributed to quick action of the firefighters.

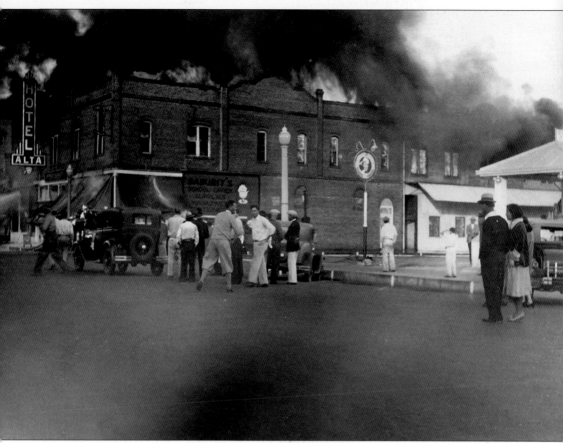

Although the hour was early, the Alta Hotel fire of 1931 brought large crowds to the northwest corner of Yosemite and C Street. It was the last day of the Madera County Fair, and many remembered that just two years prior, almost to the day, another fire had broken out on Yosemite Avenue—once again on the last day of the Madera County Fair. The conflagration that year consumed the pioneer store of Rosenthal-Kutner, then located on the southeast corner of Yosemite and E Street.

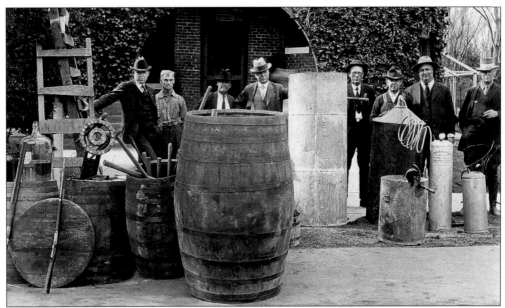

John Barnett had just been elected sheriff of Madera County when Prohibition became the law of the land, although it didn't mean all Maderans followed the law. Moonshine ran freely, especially in the mountain areas, and Barnett did his best to stamp out the illicit liquor traffic, but he clearly had his hands full. After all, there was enough crime to occupy his time without having to deal with Madera County's thirsty citizens. On December 11, 1923, however, Barnett busted a still near North Fork and brought the liquor-making machinery to the Madera courtyard and put the moonshiners in jail for selling some bad liquor to a group of high school students who became ill. After that, Barnett declared war on all illegal liquor. Pictured here, from left to right, are District Attorney Mason Bailey, unidentified, Jack Rea, unidentified, Andy Clark, Undersheriff Clarence Osborn, Sheriff Barnett, and unidentified.

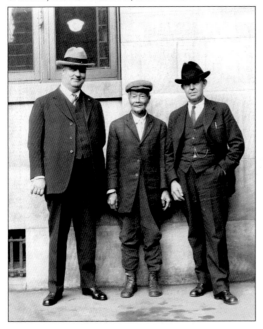

Madera's Chinatown, which was bounded by West Yosemite Avenue, I Street, Central Avenue, and F Street, received much attention from Sheriff John Barnett. The area was filled with subterranean tunnels that provided a welcome haven for opium smoking and gambling. On this particular occasion, Barnett raided Ah Coon's hideout because of persistent reports that Madera teenagers frequented his place. Shown here c. 1921 are Sheriff Barnett, Ah Coon, and Undersheriff Clarence Osborn.

On November 10, 1923, Clarence Pickett became Madera's first police officer to die in the line of duty. Spotting a Dodge Coupe with four men in it traveling north toward Berenda, Pickett pulled the car to the side as an automobile that matched the description of the coupe reported stolen. The lawman got off of his motorcycle and walked up to the car. As he was checking identification papers, Walter Yeager and H. B. Terry shot and killed him. They were later caught and tried in Judge Conley's court in Madera. Yeager was given the death sentence, and Terry received a life sentence. On Friday morning, January 9, 1925, Yeager climbed the steps to the gallows in San Quentin Prison and, with no sign of contrition, paid for his crime. Among those in attendance at the hanging was Sheriff John Barnett. Although he didn't get to see the condemned killer squirm, he was content with the knowledge that Yeager paid for his wanton act with his own life, even if it had meant little to him. Shown here, from left to right, are traffic officers Ernest McCloskey, Andy Clark, and Clarence Pickett.

Clarence Pickett, the first Madera police officer to die in the line of duty, is shown here c. 1922 on his Henderson motorcycle. He was killed with a .45 caliber pistol at the hands of two men who were running from the law. Pickett had been married just two months earlier.

After killing Madera police officer Clarence Pickett, Walter Yeager and H. B. Terry hopped back in this Dodge Coupe and sped away. Their flight, however, was futile. A huge manhunt was quickly put into place and the two fugitives were caught near Dixieland School. The bullet holes put into their getaway car by posse members can be seen in this photograph. After Yeager and Terry were taken to jail in Madera, an ugly mob assembled in Courthouse Park, and there was serious talk of lynching the men. Sheriff John Barnett took them to the Merced County jail, but the mob followed, so the prisoners were whisked away once more, this time to Stockton, where they remained until they were brought back to Madera for trial.

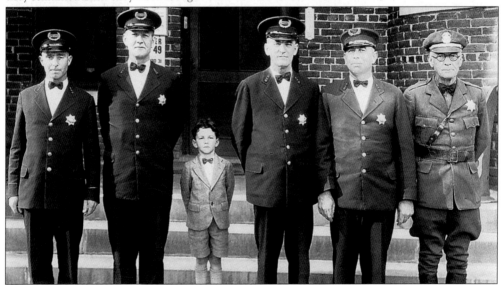

The Madera Police force in the 1930s included Lloyd Cook, Walter Thomas (who became chief), Andrew Mitchell, Logan Wells, and Andy Clark. The young boy is the son of Walter Thomas.

Such was the reputation of Sheriff John Barnett and Undersheriff Clarence Osborn that they are remembered today as "the untouchables" to city residents. At this particular time, the two were involved in an undercover operation to close down a house of prostitution in compliance with California's Red Light Abatement Act. The two lawmen are in the auto on the left in this *c.* 1925 photograph.

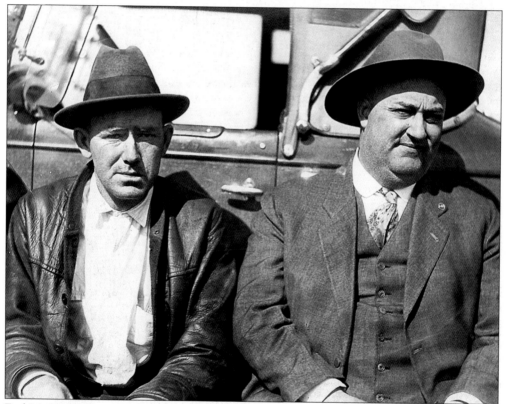

Earl McCrory was one of Chowchilla's most prominent citizens. As the manager of the San Joaquin Power and Light Company, he welded considerable influence in his community. That is why folks were so surprised when Sheriff John Barnett charged him with bank robbery in 1923. Shown here sitting on the running board of Barnett's car, McCrory had just revealed where he stashed the bank's money. Ironically, he had buried it at the base of a newly placed power pole. McCrory was sent to prison after his trial in Madera.

In 1924, hoof-and-mouth disease struck Madera County livestock, and herds of cattle and bands of sheep were taken to this ditch, where they were dispatched to save the rest of the industry. This photograph, taken along River Road, shows the animals before they were shot.

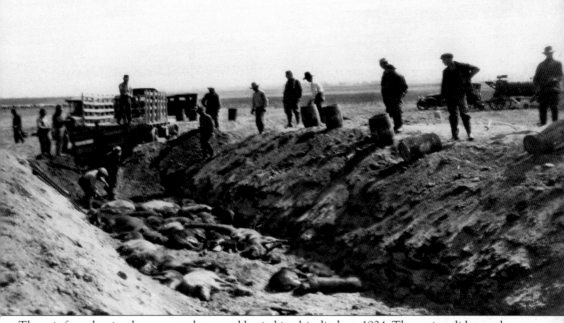

These infected animals were put down and buried in this ditch, *c.* 1924. The action did save the cattle and sheep industry in Madera County.

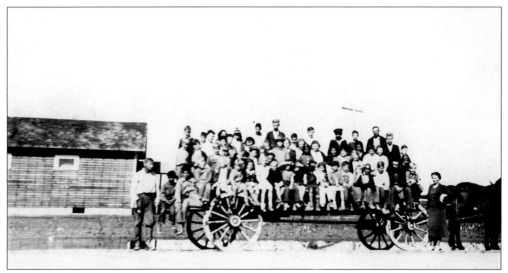

In the 1930s, Madera County became home to large groups of refugees from the dust bowl of Oklahoma. As a result, most schools had to develop special "migrant education" facilities for the children of the down-and-out transients. Shown here is the migrant-education "bus" for La Vina School. These children were on their way to their school. They had little contact with the children of Madera County's permanent residents.

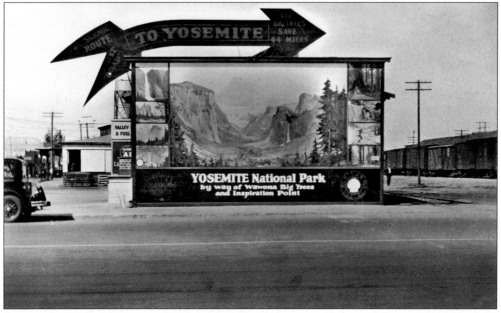

During the 1930s, Maderans advertised that the best way to Yosemite National Park was still through their town. For several years, Madera had a monopoly on transportation to the park. The route to Yosemite from Madera was built in 1877, and stages took visitors there until 1885, when the Southern Pacific laid tracks from Berenda to Raymond. Visitors then shifted there and took the train to Raymond, after which they boarded a stage for Wawona. Nevertheless, as this photograph clearly shows, Madera did not give up easily. It continued to promote Yosemite travel through Madera. This sign was on the northeast corner of Yosemite Avenue and F Street. Note the Valley Feed and Fuel sign in the background.

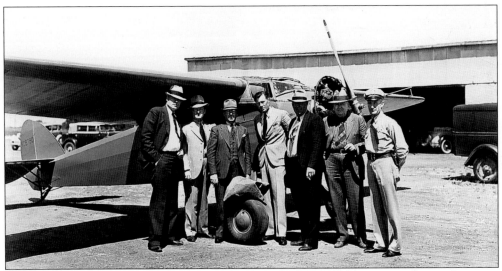

The 1930s were propitious times for the U.S. Postal Service in Madera and for Postmaster E. V. Murphy. It was under his tenure as chief of Madera's postal operations that a new post office was built on the corner of D and Sixth Streets and the first shipment of airmail from Madera was made. Shown here c. 1938 are city councilman Irvine Schnoor, Mayor John Gordon, Murphy, pilot Pete Schmidt, councilman John Wesley Smith, councilman Matt Davis, and fire chief John Brammer.

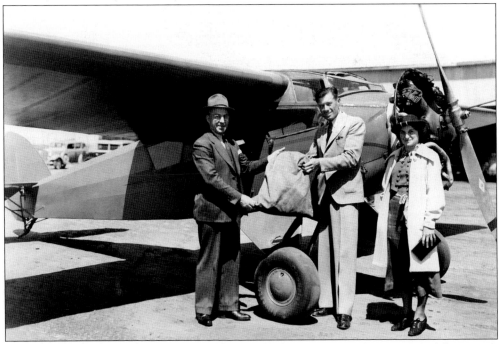

Airmail to Madera was not exactly a new thing. In 1912, the city was the recipient of the nation's first airmail delivery when Glen Martin zoomed over the city and dropped a bundle of newspapers from the sky onto Yosemite Avenue, but airmail never left Madera until Postmaster Murphy decided to change that in 1938. In this photograph taken on May 19, Murphy hands a sack of mail over to pilot Pete Schmidt while *Madera Tribune* reporter Winifred Peck looks on. With Ms. Peck as a passenger, Schmidt took off from what is now Lion's Town and Country Park on Howard Road.

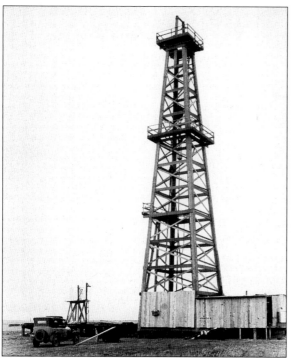

Maderans have always been open to economic innovation, no matter how risky. Gold, silver, and copper mining have lured fortune hunters to the hills and streams of Madera County. In the 1930s, however, it was black gold in the flat lands that had some folks excited. Two or three wells were drilled in the southern part of the county, but they all proved to be a waste of time and money, including the one shown here *c.* 1938.

In 1927, the Webster School student body numbered 20, including 3 children of the teacher, Mrs. Mary Alice Cunningham Pitman. Shown here with their mother and their classmates are Robert Pitman (first row, far left), Rinard Pitman (second row, second from left), and Willard Pitman (third row, fourth from left). Webster School still exists, but it is in a new building and is part of the Golden Valley School District.

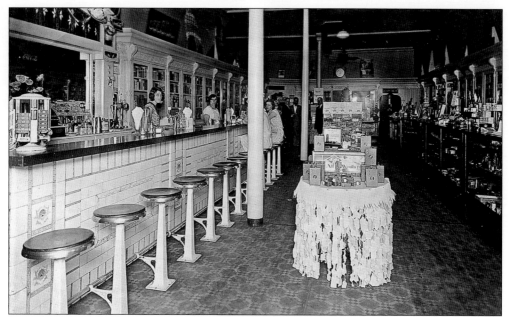

As Madera grew, so did Hunter's drugstore. With this new soda fountain, they began to make their own ice cream as they used a gasoline engine to turn the freezer. The fountain was open from May through September and 10 different kinds of ice cream were offered to customers. W. W. W. Hunter had two well-known slogans: referring to his ice cream, he called it "the best west of the Mississippi"; of his pharmacy he was often heard to say, "We have a pill for every ill."

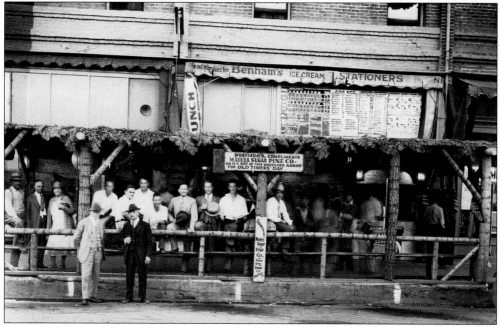

The sidewalk in front of Preciado's store on the corner of Yosemite and D Street was often a meeting place for Maderans who wanted to learn the latest news that was posted on the bulletin board in front of the establishment. This particular photograph was taken on October 31, 1931, during Madera's first Old Timer's Day celebration.

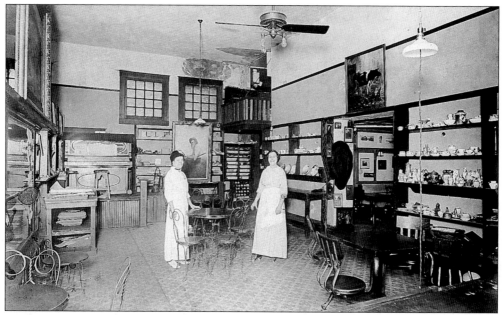

Perhaps the most popular part of Preciado's store was the Arbor Nook, where Madera High School students could gather and enjoy each other around a soda or a dish of ice cream. The driving force behind the Arbor Nook was Carmelita Precido, shown here on the left.

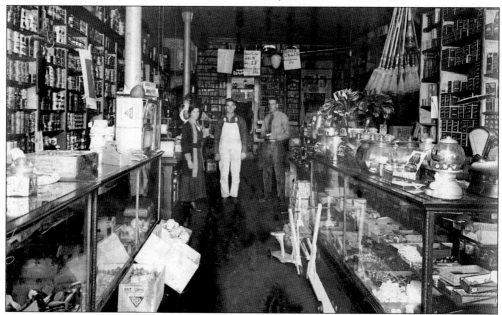

C. W. Petty opened this store after his first try at business in Madera went up in smoke. The Pennsylvania transplant had been in Madera for two or three years when, in May 1901, he announced that the town was going to have a new factory, which would produce matches. It was an instant success, and Petty's future looked bright. Unfortunately, tragedy struck less than a year later when Petty's match factory caught fire and burned to the ground. With no insurance, it was a total loss, so Petty turned in another direction and opened C. W. Petty and Son's grocery store on Yosemite Avenue.

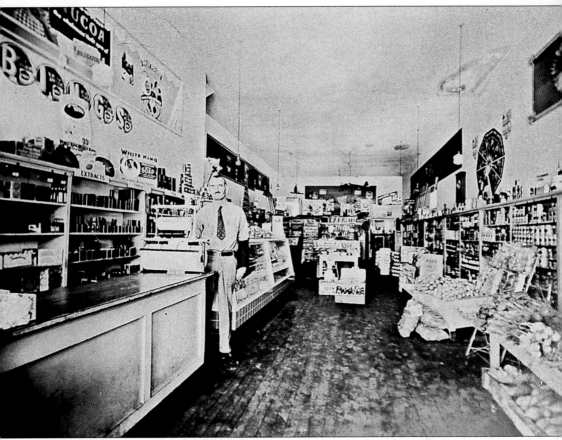

C. M. Petty let go of his vision of operating a match factory, but he didn't give up on business in Madera. Always the entrepreneur, he opened this grocery store that he and his son, Willis, operated for years. Inside the store, Petty displayed several boxes of Madera matches, more as a memento than anything else. Today his descendants have what is left of that inventory—the only known remnants of the Madera match factory. Petty is shown here inside his Yosemite Avenue store, c. 1938.

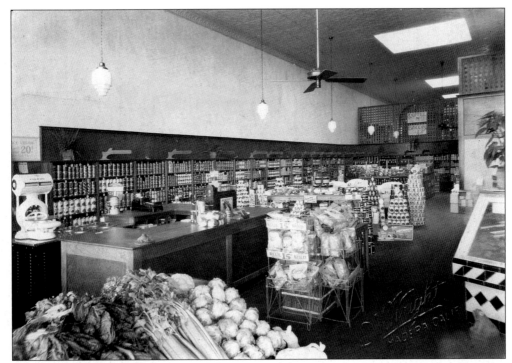

The Green Frog Market was another of the many popular grocery stores in operation on Yosemite Avenue. Housewives could order their goods here in the morning and have them delivered by noon the same day.

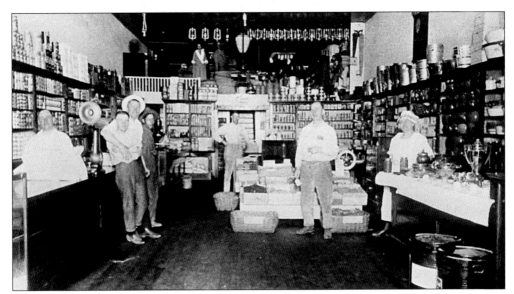

This is the A. Franchi store on Yosemite Avenue, c. 1940.

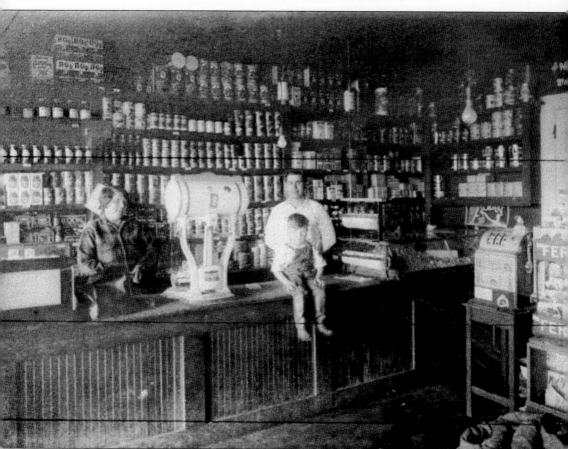

Not every grocery store in the Madera area was on Yosemite Avenue. This *c.* 1930 photograph shows the popular grocery store of Rasmeo and Pia Mariscotti in Berenda. Sitting on the counter is Bob Mariscotti, who with his wife, Helen, and son Chris now operate the elegant Vineyard Restaurant in Madera. At the time this photograph was taken, almost every place of business in the Madera area had a slot machine; note the one in the lower right corner. The safe from their store in Berenda now sits in the lounge of the Vineyard restaurant, as does a 19th-century cash register from a nearby saloon.

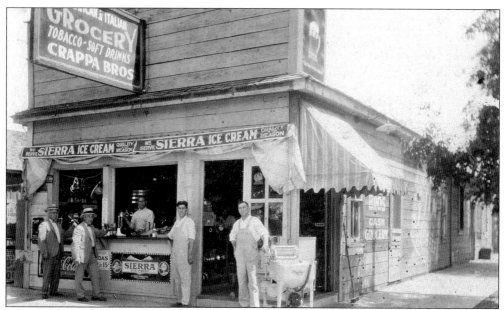

Located on the corner of Gateway and Fourth Street was the Crappa Brothers American and Italian grocery. The Italian influence in Madera was and remains very significant. After coming to America on a shoestring, they often found work on the cattle ranches of Miller and Lux or in the Sugar Pine Lumber Mill. Then with much hard work, they bought land upon which they farmed or opened businesses such as the Crappa Brothers.

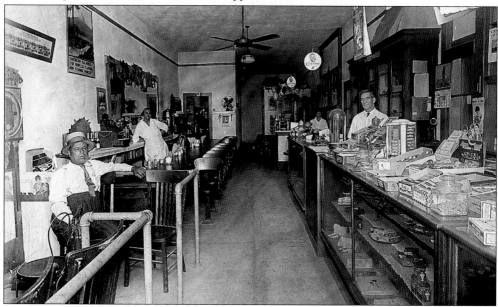

Ray and Hattie Northern's store also doubled as Madera's bus station. Prior to this business venture, Ray was Madera's first constable. He was appointed when the city was incorporated in March 1907. Hattie Quant Northern was the daughter of Frederick John Quant, a cavalry soldier who joined the California 100 and fought in the Civil War. The Northerns were the parents of the late Lena Northern Adams, who was a star on the 1915 women's basketball team at Madera High School. She was also Madera's Raisin Queen in 1914.

Pictured c. 1940, this barbershop was located on the north side of Yosemite Avenue, near the site of Y. V. Preciado's pioneer barbershop. Unlike this shop, one could get a haircut, shave, and a bath at Preciado's. Madera's premier barber closed his shop after the San Francisco earthquake of 1906.

Not every merchant plied his goods inside a store. Here one enterprising watermelon merchant sells his goods from his wagon in front of the Rochdale store on the corner of C Street and Yosemite Avenue, *c.* 1930.

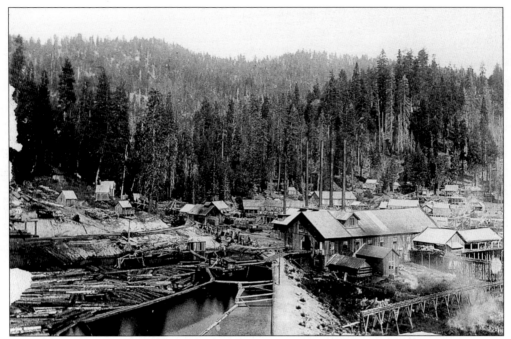

The Madera Sugar Pine Lumber Company obtained its logs in the mountains of Madera County. After they were hauled to the mill in the mountains, they were cut into rough lumber and put into the flume for a 56-mile ride down to the Madera mill, where the boards were sawed into finished planks. This c. 1925 photograph shows the mountain mill and the little town of Sugar Pine that grew up around it.

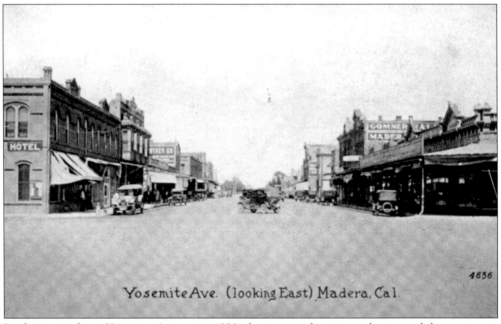

Yosemite Ave. (looking East) Madera, Cal.

Looking east down Yosemite Avenue in 1938, there are no buggies, only automobiles.

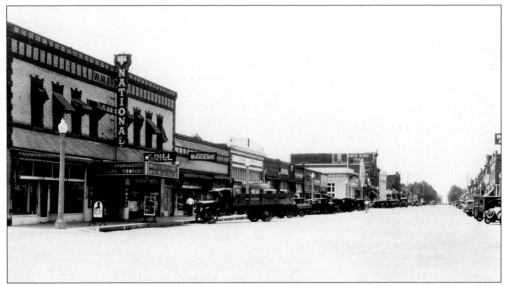

Looking west on Yosemite Avenue from B Street, the National Theater can be seen on the south side of the street. It was just one of a number of theaters that have made their appearance in Madera. In addition to the National, there was the Madera Theater, the Rex, and the Star. At one time, Madera even had a hand-cranked cinema house on South C Street. Then, of course, there was Henry Preciado's El Rio, Madera's one and only drive-in theater.

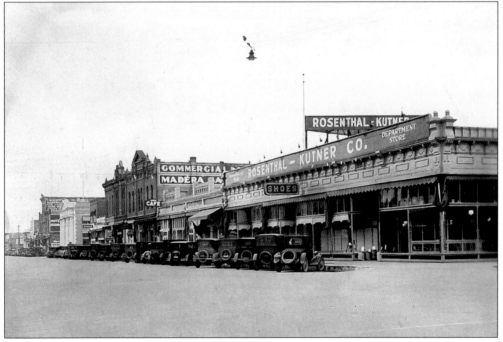

Looking east on Yosemite Avenue from E Street, this c. 1928 photograph shows the Rosenthal Kutner department store in the lower right corner. This concern had its beginning in Madera on the opposite side of the street and one block east. The building caught fire in 1929 and that ended the presence of Rosenthal Kutner in Madera. J. C. Penny's occupied the site after the rebuilding.

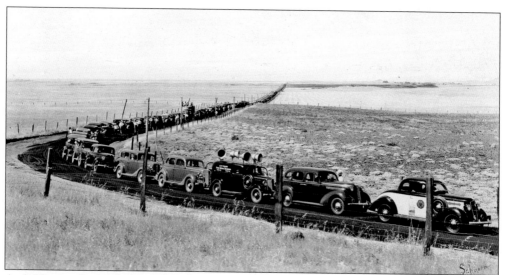

At 9:00 a.m., September 9, 1936, almost every business in Madera closed its doors. Under the auspices of the Madera Business Men's Association, a 300-car caravan proceeded from Yosemite Avenue along what is now Highway 145. Carrying over 1,000 people and headed by William M. Conley, the Maderans made their way past Little Table Mountain to the staging area for the program for the groundbreaking ceremony of Friant Dam. The only down side of the day came when the car belonging to Madera Mayor J. B. Gordan suddenly started rolling driverless down the hill, from where it had been parked, toward the San Joaquin River. Luckily it turned and came to a stop before it hit the water.

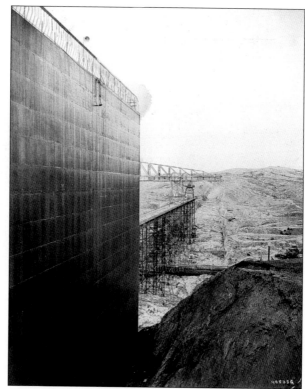

On the whole, the unveiling of the Friant Dam site was a tremendous success. Not only would the huge construction project provide more jobs, it would mean that the water of the San Joaquin River could be managed as never before.

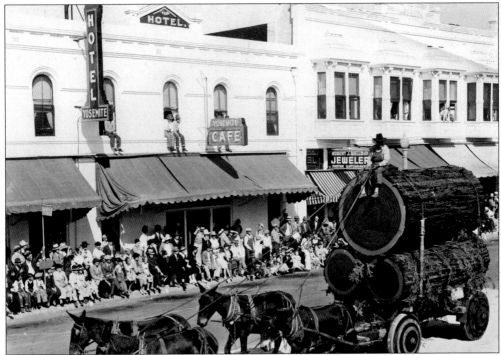

Madera's annual Old Timer's Day Parade took place for the first time on Halloween in 1931. Originally a two-mile parade, the event took a variety of people and vehicles along Yosemite Avenue, including representatives of the lumber industry, shown here hauling logs. Hundreds of observers from all segments of the community turned out to take part in the celebration and lined the streets as shown in this photograph near E Street.

"It ain't what it used to be," seems to be the theme of this entry in Madera's first Old Timer's parade. Inside the mule-drawn buggy are Merele Larson, Ella Mae Glenn, and Rae Marie Adams.

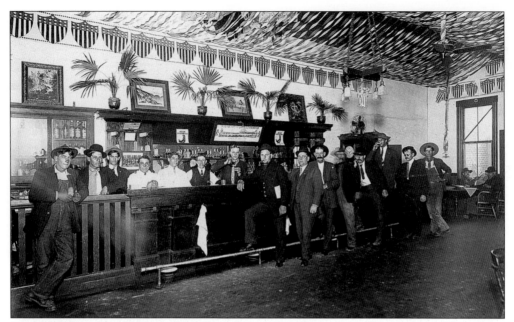

On Old Timer's Day, saloons along Yosemite Avenue did a land office business. Shown here is the Peerless saloon and pool hall, a popular watering hole next to Hunter's drugstore on the north side of the street.

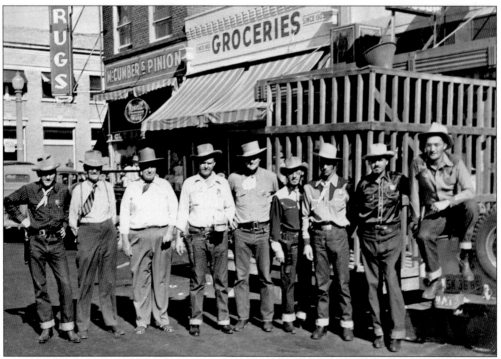

The tradition of growing beards during Madera's Old Timer's Day began in 1931. Shown here is the sheriff's beard posse, whose job it was to round up any male Maderan who did not have a beard during the celebration. They would be thrown into this makeshift jail to await someone to bail them out.

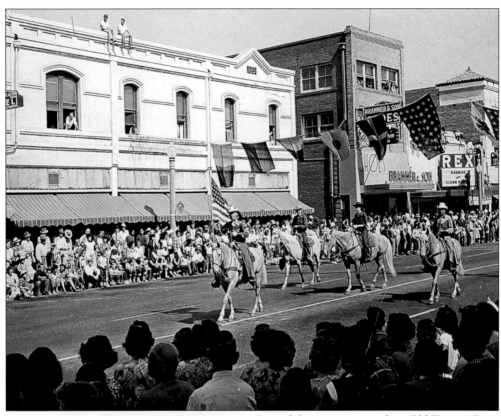

One of the most outstanding Old Timer's Day parades took place in 1947. Ten thousand people gathered for the festivities and packed both sides of Yosemite Avenue. They sat on awnings, perched on rooftops, and hung out of windows to cheer the procession as it went by. Prolonged applause greeted the grand marshall Raynor Daulton, Queen Ann McKee, and King William Tighe. The crowd all knew that this trio represented a generation that had contributed to Madera's foundation.

Even Lady Godiva appeared in Madera's 1947 Old Timer's parade, although it is doubtful that she rode through town for the same purpose as the original Lady Godiva. Maderans weren't suffering from the heavy taxes that afflicted people back in Coventry, England, in 1050.

Three of Madera's most prominent figures got dressed up in pioneer costume for the 1957 Old Timer's Day celebration. On the left is Matilda Brown, daughter of Mrs. Jennie Mace and stepdaughter of Capt. Russell Perry Mace. Matilda was the widow of Madera's first physician, Dr. C. E. Brown, who died in the 1880s. In the middle is Craig Cunningham, who first conceived the idea of Old Timer's Day and convinced the city fathers to adopt the concept in 1931. On the right is Mrs. George Goucher, mother of Merle Goucher Daulton. Mrs. Goucher's husband was instrumental in creating Madera County, as he represented the area in the California State Senate in 1893.

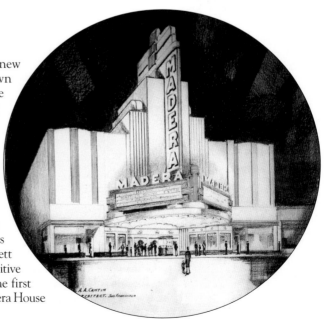

This architect's drawing of the new Madera Theater thrilled the town when it appeared in 1941. Before the year was out, the building had become a reality. Its history in Madera goes back to the turn of the 20th century before movies hit town and people were entertained in the old Madera Opera House on the corner of B Street and Yosemite Avenue. Residents flocked there to see live performances. In 1912, movies came to town when Charles Leggett turned the Opera House into a primitive theater. Walter M. Brown built the first Madera Theater to replace the Opera House in 1913.

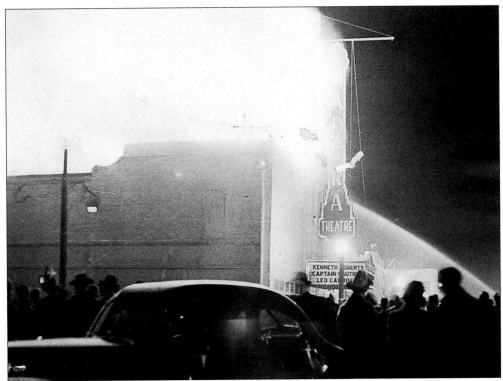

A huge and deadly fire struck the Madera Theater downtown on November 30, 1940. The blaze broke out about 5:30 p.m. and resulted in the death of volunteer firemen Clyde Hammond when he and another fireman, Owen Barr, fell through the roof when part of the building collapsed. Barr was able to survive by crawling under the water-soaked debris.

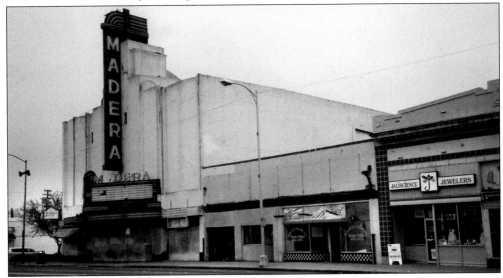

By the 1990s, the Madera Theater had fallen into disrepair and was abandoned. Several attempts were made to transform the old landmark into a community theater for the performing and visual arts, but those ideas never got past the discussion stage. After a heated debate, which divided Madera, the decision was made to demolish the building.

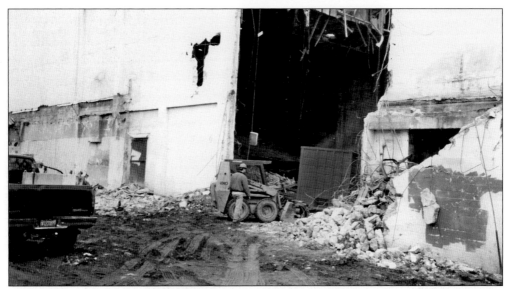

Many Maderans mourned the Madera Theater after the wrecking ball hit it. There was talk of building a new city or county government complex on the site, but this never materialized. Longtime Maderans still look with longing up Yosemite Avenue for the Madera Theater sign that seemed to let everyone know where they were.

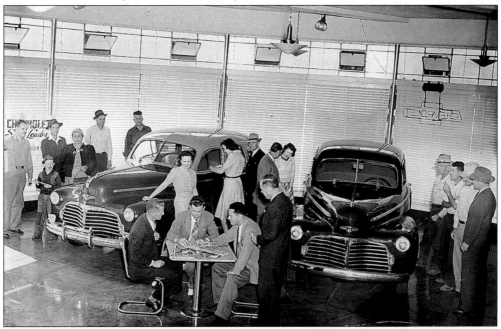

When this photograph was taken on September 27, 1941, Conrad Shebulet, standing by the table, had every reason to be optimistic, thanks to the crowds of people who were looking over the new Chevrolet models. However, with the coming of World War II, Shebulet's business took a severe downturn, as he couldn't sell any automobiles. Also shown in this photograph at the table, from left to right, are Roy Long, John Copeland, and Bill Seabury. Doris Seabury stands behind the table with her hand on the fender. Former Sheriff Marlin Young, then a car salesman for Shebulet, stands at the center of the picture, wearing a hat and looking at the camera.

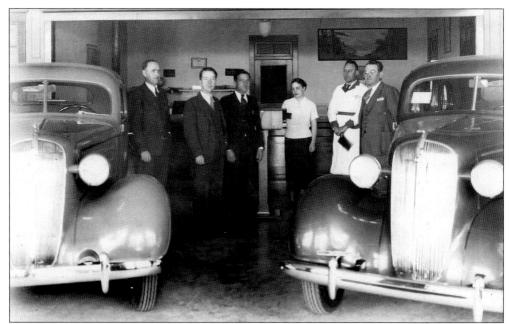

This *c.* 1938 shot of Shebulet's Chevrolet was taken on South C Street and shows salesman Pete Pistoressi, third from the left. Pistoressi was known as "Chevrolet Pete" and broke all records for selling cars while he was with Shebulet. Pete later opened a Chevrolet dealership in Chowchilla, which he operated with his sons and grandson.

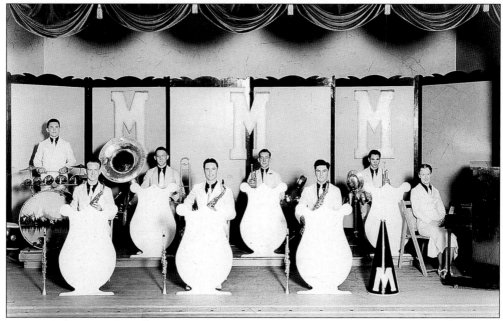

The Eddie Sims Orchestra, formerly known as the Master Melody Makers, prepared for a half-hour program in conjunction with the Harmony Hour at the Madera Theater on Thursday and Friday nights in 1940. Members of the group, from left to right, are (first row) Everett Bondesen, Richard Cook, Eddie Simonian, Dot Loveland; (second row) Bobby Brown, Jack Bick, Jean Bondesen, and Ray Phillips.

For more than 30 years, Courthouse Park was home to the Madera Zoo. Nearly everyone was acquainted with the alligator who lived there and the talking parrot that shocked folks with his language. At one time the zoo even had monkeys, but they were removed because they were constantly being teased. Anyone caught doing so, however, faced a $5 fine.

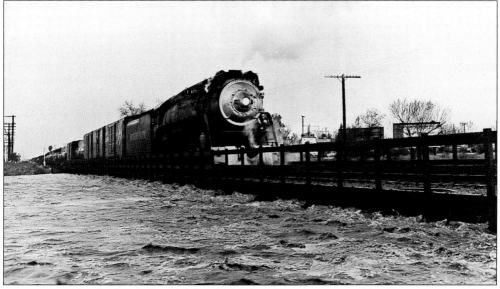

By some miracle, the flood of 1955 did not take the railroad crossing of the Fresno River, and this train was able to make it through to the depot.

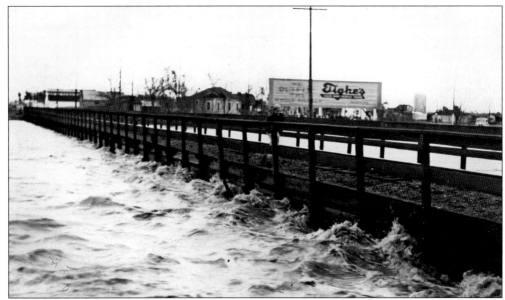

Almost always in need of water, Madera received too much of a good thing during the 1955 holiday season. On the evening of December 21, rain fell on the snow pack in the Sierra Nevada, and torrents rushed toward the valley, transforming rivulets into raging rivers of angry water. All night long, the rain continued, at the rate of a half-inch per hour. Officials became justifiably concerned about the Fresno River. Two days later, the headlines of the *Madera Tribune* screamed, "Worst Flood in Madera's History; Scores Left Homeless." The fears of many had been realized, but the center of Madera was saved from the flood by the dike that was thrown up at the Santa Fe tracks near Tozer Road.

In 1962, a snowstorm surprised Maderans and created havoc on Yosemite Avenue. On January 22, the headlines of the *Madera Tribune* told this story: "Snowstorm Strikes Madera Area; Cold, Slippery Roads Force Schools to Close." Many residents of Madera remember the day, as it was the first and last vacation students of that generation would be given due to snow. The unexpected sample of eastern weather produced snowmen in almost every yard, sledding on the streets, and tobogganing on the slopes around Lake Millerton. This photograph shows a snow-covered Yosemite Avenue looking east from E Street.

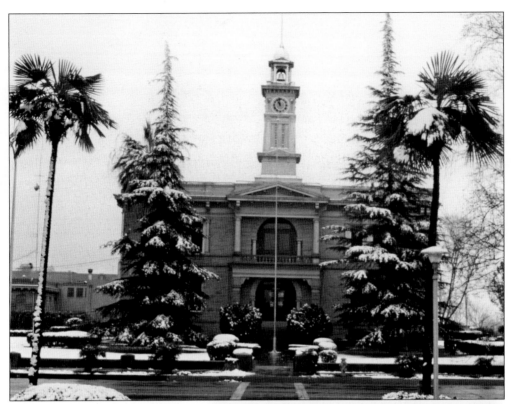

With school out, many youngsters flocked to Courthouse Park to build snow forts and throw snowballs. There was plenty of the white stuff to give the place a winter wonderland, postcard appearance.

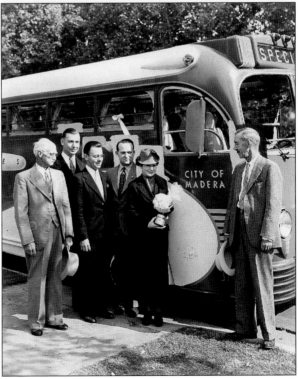

The *City of Madera* was created in the 1950s by the Greyhound Company, for advertising purposes. Shown here greeting the bus are A. D. Cook, Madera city councilman; Herbert O. Coiford, from the Greyhound advertising department; Joe Romondini, another Greyhound official; Mayor John B. Gordon; Mrs. Patricia McKinnon; and the unidentified secretary of the Madera Chamber of Commerce.

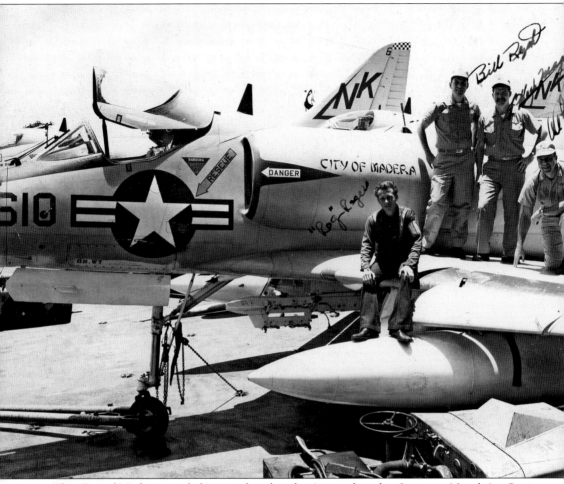

This *City of Madera* traveled in another decade. A crew based at Lemoore Naval Air Station wanted to keep its connection with the San Joaquin Valley while serving in the Vietnam War, thus their plane was named after Madera. Posing *c.* 1968 with the craft before a mission are, from left to right, "Rog" Rogers, aircraft mechanic; Bill Rezek, pilot; Hugh Magee, pilot; and A. A. Schaufelberger, commanding officer of the attack squadron. The plane was hit once during a mission but continued to fly.